CHRIS JONES

PAINTING SOLUTIONS

BUILDINGS

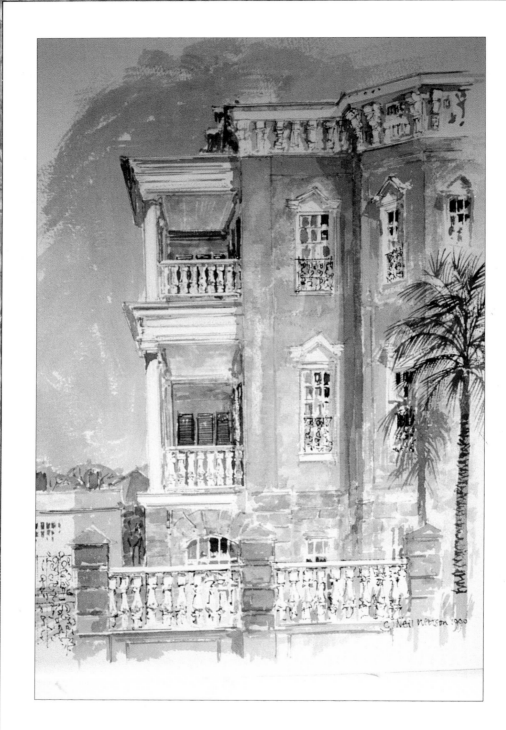

Windows and Balconies Neil Watson, *watercolour*

PAINTING SOLUTIONS

BUILDINGS

HAZEL HARRISON

THE WELLFLEET PRESS · WELLFLEET

A QUARTO BOOK

Published by Wellfleet Press
110 Enterprise Avenue
Secaucus, New Jersey 07094

ISBN 1-55521-721-4

This book was designed and produced by
Quarto Publishing plc
The Old Brewery, 6 Blundell Street
London N7 9BH

Publishing Director Janet Slingsby
Art Director Moira Clinch
Assistant Art Director Chloë Alexander
Picture Manager Sarah Risley
Picture Researcher Bridget Harney
Senior Editor Cathy Meeus
Designer John Grain
Photographers Paul Forrester, Trevor Wood, Ian Howes
Special thanks to Ray Evans, David Curtis and John Lidzey
Typeset by Bookworm Typesetting
Manufactured in Hong Kong by
Excel Graphic Arts Company
Printed in Hong Kong by Lee-Fung Asco Printers Limited

CONTENTS

Introduction 6

PART 1 **First Principles**

Understanding Buildings *10*
Linear Perspective *14*
Simple Perspective *16*
Complex Perspective *18*
ART SCHOOL Working from Photographs *22*
Architectural Details *24*
Curves and Ellipses *28*
ART SCHOOL Using a Drawing Frame *32*
Shadows *34*
Reflections in Water *36*
Buildings in Proportion *40*
LEARNING FROM THE MASTERS *42*
ART SCHOOL Making the Underdrawing *44*
Watercolor Demonstration *46*

PART 2 **Interiors**

Interior Perspective *52*
Painting the Familiar *56*
LEARNING FROM THE MASTERS *58*
Natural Light *60*
ART SCHOOL Recording Light *64*
Artificial Light *66*
Inside Looking Out *68*
Inhabited Interiors *72*
Pastel Demonstration *74*

PART 3 **Pictorial Values**

80 Viewpoint
84 Composition
88 ART SCHOOL Working with Photostats
90 Lighting
94 ART SCHOOL Painting on Location
96 Texture and Pattern
100 ART SCHOOL Texturing Techniques 1
102 ART SCHOOL Texturing Techniques 2
104 Light and Dark
108 High Contrast
110 Keeping the Colors Clean
112 ART SCHOOL Broken Color
114 Creating an Atmosphere
116 Focusing In
120 Human Interest
124 ART SCHOOL Learning to Sketch
126 Recession
128 Brushwork
132 LEARNING FROM THE MASTERS
134 Buildings in Landscape
138 Oil Demonstration

142 Index
144 Credits

INTRODUCTION

Buildings have provided the inspiration for many great paintings, yet unfortunately they are a subject amateur artists often go out of their way to avoid because they find them difficult to render effectively or attractively. In fact, as this book shows, drawing and painting houses and cityscapes is no more difficult than drawing and painting trees and fields. Indeed, in many ways, it is easier. To make a tree look realistic, you have to rely entirely on your own powers of observation; in the case of buildings, you have a set of rules to help you out right from the beginning, the starting point being the rules of perspective.

Beginners tend to be afraid of the very word perspective, but there is no reason at all for such fears. The most important thing is not to allow yourself to be put off: the basic rules are really not hard to grasp, as you will see in the first part of this book. Once you have learned to recognize these rules as friends rather than foes, you will find yourself working confidently and enjoying your drawing and painting more as a result. No longer will you end up abandoning an

Reflections Sandra Walker,
watercolour

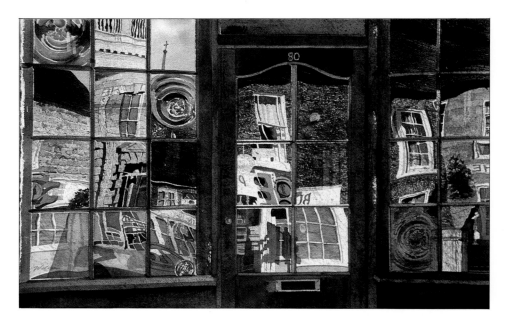

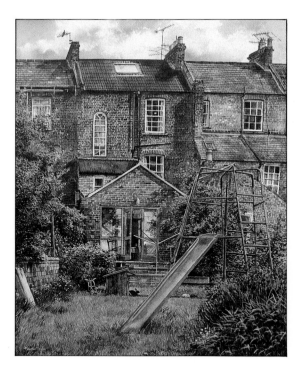

Nextdoors Martin Taylor,
watercolour

otherwise promising painting in despair because the arch of a bridge somehow looks wrong, a flight of steps rises at an unrealistic angle, or a wall appears to be toppling over.

Perspective is really just an alphabet. Once learned, it can be put aside to allow you to get on with the important part of picture-making, which is what I have stressed in the later sections of this book. The second part is concerned with painting interiors, a lovely but often undervalued subject, while the third advises you how to make your paintings work in terms of composition, colour and painting method.

Throughout, there are explanatory diagrams and a wide selection of paintings by well-known artists working in a variety of media to help you along the way. Each section ends with a step-by-step demonstration, with special features explaining a variety of helpful techniques. In each chapter there is an analysis of a painting by a noted artist from the past, providing valuable insights for the artists of today.

Whether you are a complete beginner or a more experienced artist who simply needs a little help with some aspect of your work, I hope you will find something here to inspire you and encourage you to persevere.

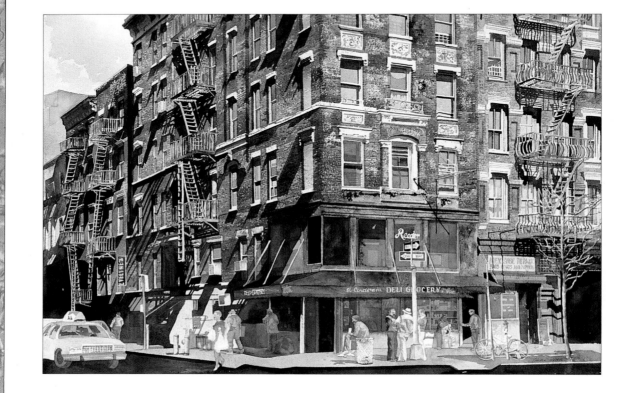

Bowery I Sandra Walker, *watercolour*

PART 1

· ·

FIRST PRINCIPLES

· ·

EVERYONE HAS TO LEARN TO WALK BEFORE THEY CAN
RUN, AND THIS SECTION SETS OUT SOME BASIC RULES
YOU NEED TO MASTER BEFORE YOU CAN DRAW AND
PAINT WITH CONFIDENCE.

UNDERSTANDING BUILDINGS

· ·

What do I need to know about architectural styles?

▼ **Manhattan Skyscrapers**
Ray Evans
All the drawings on these pages are by the same artist, who originally trained as an architect. He later learned the expressive side of drawing and the use of sketchbooks, of which he now has an extensive collection. The best way to learn the different characteristics of buildings is to make visual notes in this way whenever you can. This pen and ink sketch took under an hour, though the beginner must be prepared to spend rather longer.

I was discussing this topic recently with a friend of mine, an architect-turned-painter, and we found that we had a difference of opinion. He feels that his training in architectural history and drawing is indispensable to the way he portrays buildings, while I believe that if a subject attracts you strongly enough you will in time be able to paint it.

Trained architects like my friend can draw and paint typical houses of a certain period with speed and assurance because they know that the builders always followed certain rules of shape and proportion. They know which building materials were in use at the time, and what the ground elevations looked like. This certainly cuts down on time spent in trial-and-error, but you do not really need to know about plans and elevations, and you will quickly begin to notice the important characteristics of buildings for yourself. You will discover these by drawing and painting them, and your pictures may be the better for having constituted something of a voyage of discovery.

Personal approaches
It should be said that the degree of knowledge that you need or want depends to some extent on how you approach your subject. If you intend to make a detailed and faithful study of a well-known palace, cathedral, Classical temple or acclaimed public building you do not *have* to know anything

▲ **Flour Mill, Oklahoma** Ray Evans
Always try to make your sketches as informative as possible so that you can use them as a basis for painting. In this quick drawing all the important elements have been recorded: the building's height and proportions, the wooden plank construction and the size and shape of the windows.

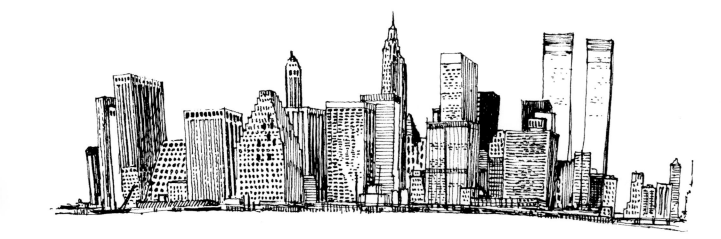

▲ Parador Nacional de Chinchon Ray Evans
This drawing of one of Spain's prestigious state-owned hotels was done for a brochure. Commissioned work must be as accurate as possible while still conveying a flavour of the place.

about the architect or even who he was. But in such cases you are reproducing, or reinterpreting, the creation of someone else, and this person has given a great deal of time and thought to his design, so if nothing else it is a mark of deference to try to understand his aims.

However, you may be more interested in the building's atmosphere, or the play of light on its surface, in which case its designer is less important than your own response. The

▼ Harper's Ferry, Virginia
Ray Evans
Although a relatively quick sketch (it took slightly over an hour) this has both a strong sense of atmosphere and considerable detail.

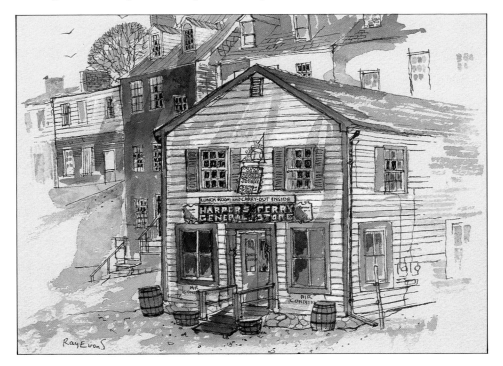

great French Impressionist, Claude Monet, painted a marvellous series of pictures of Rouen Cathedral, each under a different light, treating the subject much more as landscape than as architecture.

J.M.W. Turner, on the other hand, now revered as Britain's greatest landscape painter, trained as an architectural draughtsman, and throughout his life derived a steady income from topographical painting, or "view painting" as it was then called. There would not have been such a ready market for his views if the buildings had not been faithfully depicted.

So it is really up to you. If you think you may be able to sell your work – and well-observed paintings of places and particular buildings are still much in demand – the more you can learn, the better your chances of success. But if you paint purely for your own pleasure, you do not need to reach for the dry tomes on architecture yet..

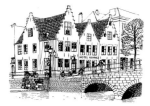

▲ Hotel Adonis, Bruges Ray Evans
The tiled roofs and stepped gables are what give this building its particular character, together with the unusually large windows. Always try to look for the essentials, just as you would when drawing a portrait.

▲ Alhambra Hotel, Granada Ray Evans
Here the essentials are the round, crenellated towers and small arched windows. The artist has cleverly stressed the building's height and its hilltop site by including the upward-reaching cypresses and the group of houses far below.

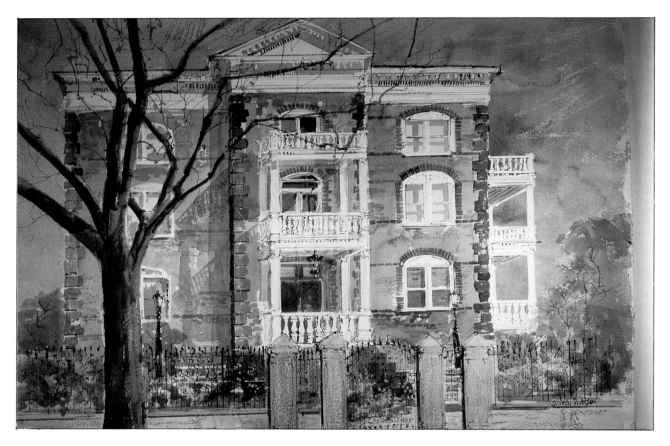

▲ **Charleston, South Carolina** Neil Watson, *watercolour*

The artist has chosen an uncompromising frontal view in order to express the character of the building, with its fine proportions and elegant detail. The texture of the walls is cleverly suggested by slightly uneven washes of colour, with individual darker-coloured bricks picked out with confident brushstrokes. The slatey blue of the sky and warm brown of the building combine to provide the perfect foil for the white woodwork, which is simply the bare paper with occasional small dark lines of definition.

◀ **Summer Pavilion** Moira Clinch, *watercolour*

Every detail has been recorded with faithful accuracy in this delightful study, indeed the intricate pattern of the painted ironwork is the main *raison d'être* of the picture. A watercolour like this can easily begin to look tired and overworked, but this one has lost none of the freshness and sparkle associated with the medium, and the pale sugar-candy colours have been controlled with great skill.

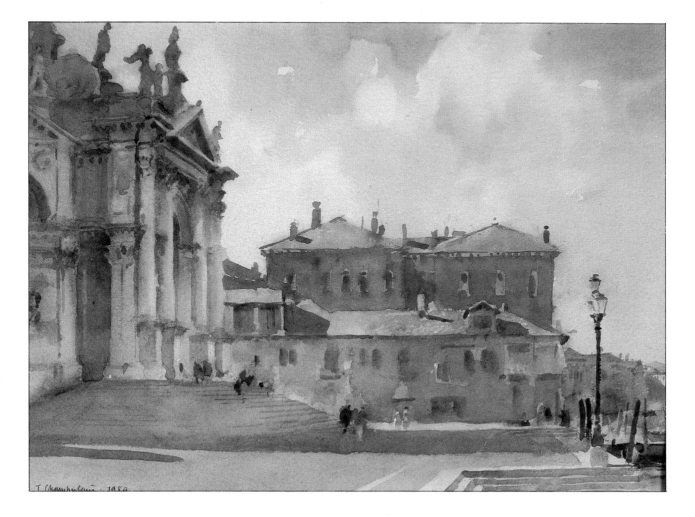

▲ **Terracotta and Stone, Venice** Trevor Chamberlain, *watercolour*
This is a more impressionistic treatment than the other paintings on these pages. Chamberlain's central preoccupation is with the effects of light, and he has exploited the contrast between the cool grey stone church and the warm brown houses beautifully, working mainly wet into wet to give an overall impression of softness. A careful underdrawing is needed for this approach, as corrections and overworking would destroy the effect.

◄ **The Rows, Chester** Moira Clinch, *coloured pencil*
The lovely patterns created by the Elizabethan timbering are a gift to the artist, and Clinch has made the most of them. As in her painting opposite, she has given equal attention to each area of the picture, and has chosen her viewpoint carefully to make an interesting and lively composition.

Q & A
LINEAR PERSPECTIVE

How much does perspective matter?

Many people are afraid of drawing and painting buildings because they already know the answer to this question. They have guessed correctly – perspective matters a lot. But you will not make the problem go away by avoiding architectural subjects, because perspective matters whatever you are trying to represent – a landscape with a river winding into the distance, a bowl of fruit on a table top, a chair, a group of figures, or even a single figure.

The feelings of gloom and inadequacy that most people experience at the thought of learning perspective are not surprising. I was recently looking through an encyclopedia article on the subject, and was horrified by the complexity of the diagrams and the impossibility of relating them to anything real, such as a house, or even a table. But it need not be made as difficult as this, and I hope that the drawings and diagrams that you will see in this section of the book will dispel some of the darkness.

▲ **Hotel Virgilio, Orvieto**
Ray Evans
Here perspective has been used to give a feeling of space, with the diagonal lines created by the wide sweep of steps leading the eye towards the group of buildings.

▶ **The Sign of the Angel, Lacock** Ray Evans
It would be difficult to draw a subject like this, which has a good deal of complex detail, without knowing something about perspective. Once you have established the vanishing point (explained and illustrated on the next page) you can work with confidence.

Optical trickery

Because the real world is three-dimensional and a painting is a flat surface, artists have over the centuries evolved a series of conventions, or tricks, to translate one into the other. Linear perspective is the most important of these, providing a way of making objects look solid and convincing by suggesting space and volume. (There is another kind of perspective, called aerial perspective, which is concerned with tone and colour. This will be explained in Chapter 3.)

In a way, perspective is the easiest part of painting because it is simply a set of rules that can be learned. The more advanced aspects of art, such as composition or the use of particular colours and shapes to create a specific mood, can involve a long-term personal quest and the conventions adopted are different for every artist, but perspective is the same for everyone. Once you have become familiar with the rules you will find that you can draw with much more confidence because they will have become second nature to you.

The mathematical laws of perspective were invented in Renaissance Italy by the architect Filippo Brunelleschi, and came to exert a great fascination for artists, notably Paolo Uccello. The latter apparently used to work far into the night, producing ever more intricate and complex drawings of multi-faceted objects, and the story goes that when his wife implored him to come to bed he simply sighed, "Oh what a sweet mistress is this perspective".

Although it is unlikely that many of us will share the strength of his passion, it is not hard to grasp why he felt so strongly. The newly formulated rules set him free to develop as a painter, and they can do the same for you. You may choose to ignore or distort perspective in the interests of a different kind of truth to the subject – rules, after all, are made to be broken. But in order to break them you must first learn them, so read on.

▼ **Behind Waterloo Station**
Sandra Walker, *watercolour*
Again perspective has become a compositional tool, with the gentle curves and arches receding into the distance to create both space and a sense of flowing movement.

· · · · · · · · · · Q & A · · · · · · · · · ·
SIMPLE PERSPECTIVE
· ·

What are the basic rules?

If you have a mathematical bent you could probably devote much of your life to the study of perspective, but this book is about buildings, so it makes sense to follow the "need to know" principle and keep matters as simple as possible. The whole system of perspective is founded on one basic tenet, which can be readily observed by eye – the apparent decrease in the size of objects as they recede towards the horizon. Suppose the objects in question are a series of simple cubes, as shown here – then it follows that the side planes will appear smaller the further away they are. And to make this happen the parallel lines have to become closer and closer together (a geometrical impossiblity but an optical fact) until they eventually meet on the horizon line.

The vanishing point

This brings us to the golden rule that all receding parallel lines meet at a vanishing point, which is on the horizon. This sounds simple, as indeed it is, but where, you may ask yourself, is the horizon? It is easy enough when you are looking at an expanse of sea or a flat landscape – the horizon is where the land or sea meets the sky – but where is it located when you are in the middle of a city and can see nothing but houses? The answer is that the horizon is exactly at your own eye level, and this is what determines where the lines will converge. Normally, when you are sitting sketching or simply walking about, your eye level (horizon) will be lower than the tops of the buildings, so the horizontal lines of roofs and high windows will appear to slope down, but if you choose a high eye level, for example looking down on a group of houses from the top of a hill, the horizontal lines will slope upwards.

Establishing the vanishing point is the essential first step when drawing and painting buildings, because it gives you a definite framework on which to work – the angle of every horizontal, from the top of a roof to the bottom of a door, is determined by it.

If you are in the middle of a street, with a row of houses on either side, nothing could be easier – the vanishing point is

▲ Plotting the apex of a roof

A common mistake with buildings seen at an angle is placing the apex in the real middle of the wall rather than the visual middle (perspective makes the nearer half appear larger). First mark in the top and bottom lines, which in this case will meet at a vanishing point outside the picture, then draw diagonals from one corner to another. The point where they intersect is the "middle", so now take a vertical line up through this point.

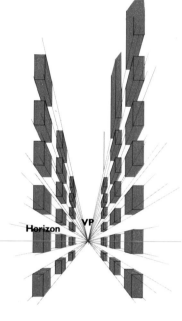

▲ Parallel lines converge

Notice how steeply the top row of cubes slopes down to the horizon. When you are drawing a high building it is easy to underestimate this angle.

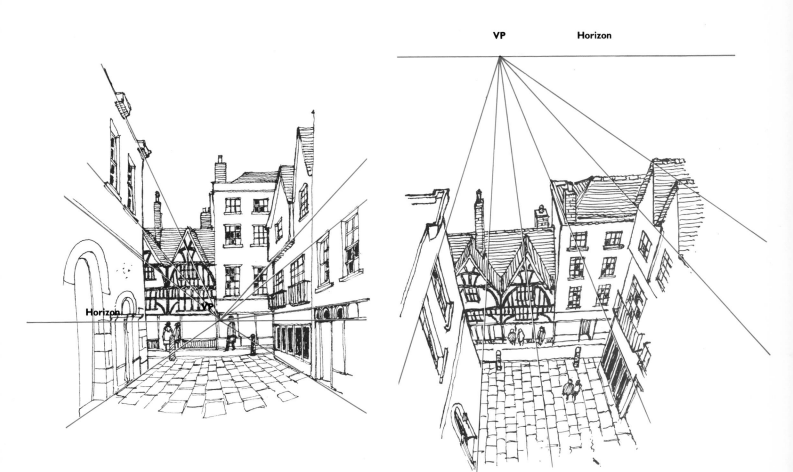

VP Horizon

Horizon VP

▲ **One-point perspective**

This is the term for the simplest kind of perspective, in which all the receding horizontal lines meet at the same vanishing point (called VP in this and all subsequent diagrams). In this case the artist has drawn from the middle of the street, so the vanishing point is in the centre of the picture. If he had been further over to the right it would have been somewhere on the left. Often it is outside the picture, as in the drawing on the opposite page (left), so you have to estimate its position.

directly in front of you and at your eye level. First mark in the horizon line and then lightly rule as many lines as you need to establish the diagonals of rooftops, window lines and so on.

If you are viewing at an angle, however, the vanishing point will no longer be in front of you and you will have to work out its position. Mark in the horizon as before, draw in the nearest vertical to the required height and then assess the angle of the rooftop by holding up a pencil or ruler in front of you. Extend this line to the horizon, and you have your vanishing point.

Sometimes the vanishing point will be outside the picture area, in which case a certain amount of guesswork is involved, combined with careful observation. If you are making preliminary studies for a painting, or perhaps just drawing for practice, it helps to work on a piece of paper considerably larger than the picture area, so that you can mark in the vanishing point or points.

I have used the plural deliberately because, of course, there is often more than one, so turn the page for some advice on coping with more complex perspective.

▲ **High viewpoint**

This is still one-point perspective, but because the scene has been viewed from above the receding lines slope upwards to the vanishing point instead of down, as in the drawing on the left. When you are working on location it is very important not to change your viewpoint, as this immediately alters the perspective. Try this out by holding up a ruler in front of you and then moving your head, or even shutting one eye.

17

· · · · · · · · · · · Q & A · · · · · · · · · · ·
COMPLEX PERSPECTIVE
· ·

If there are several vanishing points, need I mark them all in?

Once you have grasped the principle of one-point perspective, two-point – which is what you have when you look at a building from an angle – presents no problems. The rules are the same, and it is an easy matter to plot another set of receding parallels. But you can't always do this when you have a multiplicity of vanishing points, which is often the case if you are painting a street scene, particularly in an old town. Houses are bound to be at different angles because streets will twist and turn, intersecting one another at seemingly random angles.

Moreover, they will sometimes run up or down hill. Although the rules for multiple vanishing points are the same for any horizontal planes, inclined surfaces are rather different: their vanishing point will be *above* the horizon, as shown in the drawing opposite. It is important to remember this because roofs are inclined planes, and if you try to treat them like flat ones you will be in trouble.

Draw well and paint freely

Trying to plot every single vanishing point would be a laborious waste of time, and in any case no piece of paper would be large enough, as so many would be far outside the picture area. But this doesn't mean that you can afford to forget about perspective, and you will need to make a careful drawing. The best course is to choose a key building, perhaps the one nearest to you or that in the centre of the composition. Plot the perspective for this carefully and then

Two-point perspective
When a building is viewed from an angle there are two vanishing points. If your eye level (horizon) is low – or you are drawing a tall building – the rooflines will slope downwards very steeply. If the horizon is higher and the building is low, the slope will be much gentler. Always begin by marking in the horizon line, and then assess the degree of angle of the roofline by holding up a pencil or ruler at arm's length.

Receding verticals
When you look at a building from a very low angle the verticals themselves will also seem to recede, meeting at a vanishing point far above. The effect is seldom as noticeable as in this drawing, but it is a useful rule to know. It can play an important part in composition, allowing you to create a more dramatic impression of height.

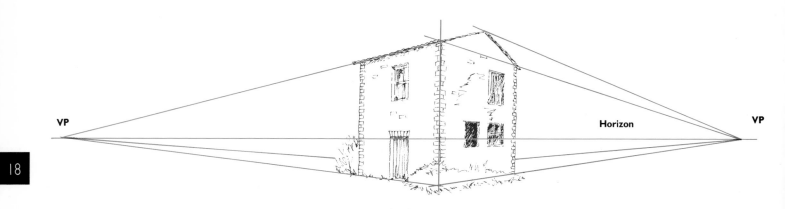

VP Horizon VP

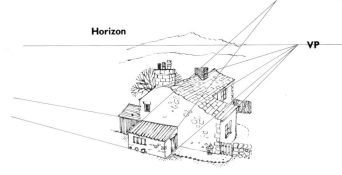

VP inclined plane

Horizon

VP

▼ Buildings on hills

This is another subject that is often misunderstood. The road is an inclined or declined plane, depending on whether it is running up or down hill, so its vanishing point is above or below the horizon. The latter, however, still determines the vanishing point for the buildings, as they are always built on level foundations. On steep hills, they usually go up in steps to compensate for the slope.

▼ Multipe vanishing points

With a complex subject like this it can be difficult to know where to start. The first step, as always, is to establish the horizon line. Then mark in the vanishing points for the main buildings and draw them as carefully as possible so that you can use them as point of reference for the others.

▲ Sloping roofs

A common mistake in drawing is to use the same vanishing point for both horizontal and inclined planes, often with bizarre results. The parallels that form the sides of inclined planes meet at a point *above* the horizon.

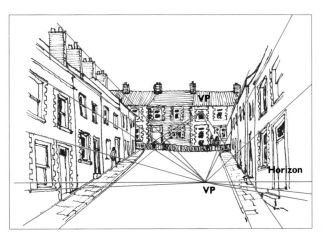

VP

Horizon

VP

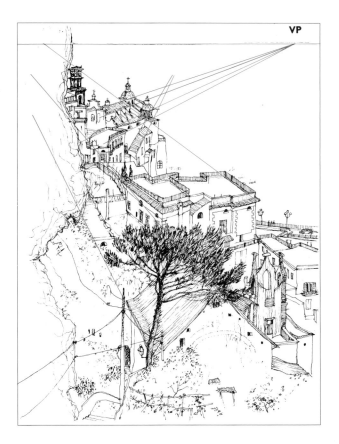

VP

draw in all the other roofs, walls and details with reference to the verticals and angles of your key.

Take your time, and keep checking your drawing against the subject, making sure that all lines intersect in the right place. Make careful measurements as you work. You can do this by holding a pencil up in front of you and sliding your thumb up and down it, or you can use a ruler.

The advantage of the latter is that you can take exact measurements, and you can also, of course, use the ruler to draw lines and to make sure that verticals are true. To do the latter, measure the distance from the edge of your picture at the top and bottom edge. You might also find the drawing frame illustrated on page 32 a helpful tool.

Don't feel ashamed of using these so-called mechanical aids. All artists employ some form of measuring system, whatever they are drawing, and there is no good reason why all drawing should be freehand. In the case of buildings, one crooked vertical can lead to a distortion of the perspective over the whole drawing. Once you start to paint, you can be as free as you like, secure in the knowledge that you know exactly where to place the colours, and any ruled lines will quickly be obscured.

If you intend to finish a picture on the spot, it is a good idea to make the drawing on one day and paint on another. The drawing will not be much affected by changing light, but the painting will.

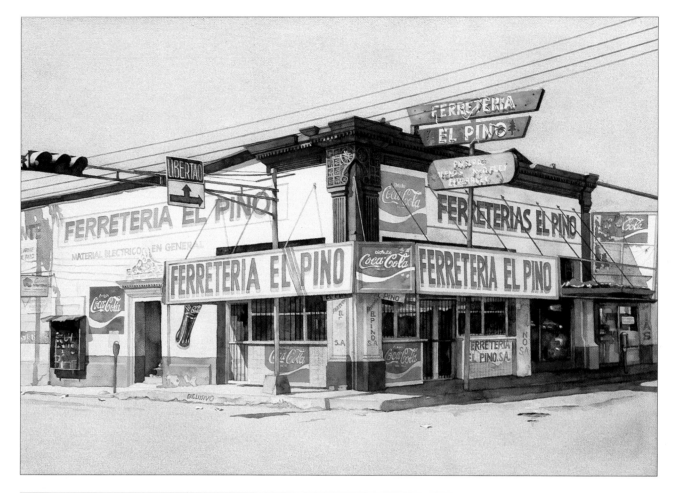

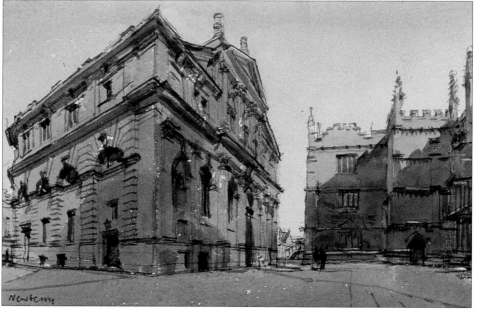

▲ **Coca-cola Stall, Mexico**
Moira Clinch, *watercolour*
Two-point perspective has provided a lively composition of verticals and diagonals, and created a satisfying feeling of solidity.

◀ **The Sheldonian, Oxford**
John Newberry, *watercolour*
This building is also seen in two-point perspective, but the horizon (eye level) is considerably lower. The diagonals thus slope at a more acute angle, increasing the sense of height.

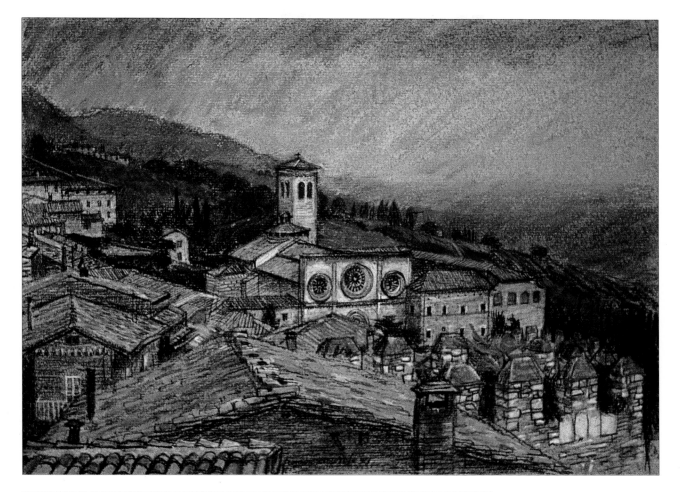

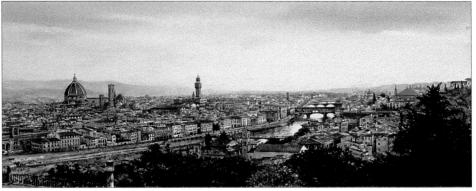

▲ **View of Florence** Martin Taylor, *watercolour*
Complex subjects such as townscapes are simplified by distance, and it is easier to see the main perspective lines. In this case the central houses follow the line of the river, and these, the bridges and the dome and towers have been treated in most detail.

▲ **Approaching Storm, Assisi** Stephen Crowther, *pastel and charcoal (study for an oil painting)*
There are several vanishing points here as the buildings are set at an angle from one another. The best way to tackle such subjects is to begin with one building – in this case it could be the foreground roof or the church and tower – and use this as a yardstick for the others. Take careful measurements of each wall and roof and keep referring back to see how they relate to the "key" building.

ART SCHOOL

· ·

WORKING FROM PHOTOGRAPHS

Ever since the camera was invented, its role in painting has been the subject of controversy. Many art teachers discourage its use on the grounds that working from photos can lead to a slavish, mechanical copying that robs a subject of excitement, while others see photographs as an important and indispensable source of reference. I belong to the latter group: it seems to me unhelpful and unrealistic to deny people something that can make drawing and painting easier and thus more enjoyable.

Photographs are particularly useful for architectural subjects, as it is often impossible to draw or paint on location in the middle of a busy street. But there certainly are a few problems associated with the use of photographs, and if you intend either to base paintings on photographs or to use them as reference for certain details you will need to be aware of them.

Perspective

The camera does not always tell the truth about perspective; it plays some nasty tricks. One of these, which everyone who has photographed buildings will have noticed, is that if you take a picture from a close viewpoint and point the camera upwards to get the roof of a building in frame, all the verticals will slope inwards, as shown in the examples here. These converging verticals can look very bizarre, and your painting will be distinctly unconvincing if you try to reproduce them faithfully in a painting. This does not mean the photograph is unusable, but you will have to remember to correct the verticals in your painting.

Focal depth

This is a photographic term, which sounds more complicated than it is. The different camera lenses "see" at different angles, which is why serious photographers carry several different ones around with them. Most standard snapshot cameras are made with a wide angle of vision to enable you to include more of a scene than you can actually see without moving your head, or "panning" in photographic terms.

▲ This photograph was taken specifically for a painting, and the very close viewpoint was the only one available. This has resulted in converging verticals, which were corrected in the painting. A more serious problem was the bleaching out of the foreground; the cobbles, which were an attractive feature of the scene, are scarcely visible.

▲ Even verticals as badly distorted as this can be corrected in a painting, though it is tricky. However, this photograph could provide valuable reference for architectural details, as it is very sharp and clear.

A 35-mm lens (slightly wide angle).

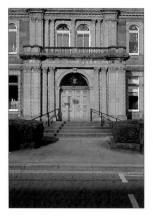

A 55-mm lens (standard).

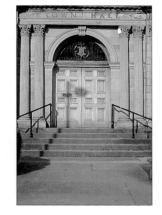

An 80-mm lens (magnification).

A 200-mm lens (great magnification)

▲ ▼ This colour negative was sent to two separate processors, giving considerable differences in colour. Always regard your prints with suspicion – they seldom tell the truth about colour.

This is fine for groups of people or for landscapes, where you want to show breadth rather than height, but it is not so good for buildings. What happens is that they look much more distant than they are, and they will also appear squashed downwards, with an untrue proportion of width to height.

This tendency is not easy to correct in a drawing or painting, because you will probably have forgotten the true proportions of the building by the time you start work. So it could be a good idea to invest in a camera with either a 50mm lens (more or less corresponding to normal vision) or a zoom lens, which can pull a distant object towards you by magnifying it. The world of cameras and photographic equipment is a complex and ever-changing one, so the best course is to seek advice from a dealer (most are only too delighted to provide it) or consult a knowledgeable friend.

Making back-up notes

Some further tiresome tendencies of the camera are to distort colour, darken shadows, bleach out highlights and refuse to reproduce vital details in sharp focus, so it is always as well to take several pictures of a subject, homing in on any interesting details that you may want to feature in a painting. And do try to make sketches as well – a quick pencil drawing with some written colour notes will often help you to understand the subject much better than photographs will. There are few artists nowadays who eschew photographic reference material, but equally few who rely on it totally: the majority use it in combination with drawings or colour sketches.

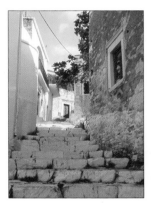

▲ ▼ In the photograph above, the shadows and highlights are well balanced, but in the one below, the shadows are much too dark. Using an automatic camera is a rather hit-and-miss affair.

ARCHITECTURAL DETAILS

I can't get the perspective right for the details. Any advice?

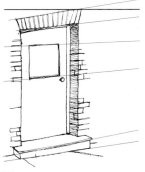

Wrong

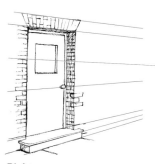

Right

▲ It is wise to mark in the perspective lines for the top and bottom of doors and windows before you start to put in details such as brickwork. And be careful about window recesses and exterior sills, which are often misunderstood (opposite). The drawings on this page show some common mistakes.

24

This is a common problem – you spend a great deal of time working out the exact angle of roofs and walls, and everything seems fine until the picture is nearly finished. Then you see that windows, doors, steps and balconies are somehow wrong, often quite subtly so, but enough to ruin the effect.

This may simply be the result of poor observation, but the well-known boredom factor often plays a part too. You have been drawing and erasing for hours and are itching to start painting. Surely, you think, the doors and windows will look after themselves? The trouble is that they will not. To position these architectural details correctly you must make sure that the top and bottom of each one corresponds to the vanishing point for the top and bottom of the building. So do not skimp on these diagonal plotting lines – it is better to mark in too many than not enough.

But this is only a small part of the problem. There is a tendency to regard doors and windows as more-or-less flat ornaments on the face of the building, but in fact, of course, they are recessed, and in old buildings particularly, the depth of the recess can be quite substantial. This brings us back to two-point perspective: you will have to establish a second vanishing point, probably outside the picture area, to take care of the angles where the side of the recess meets the

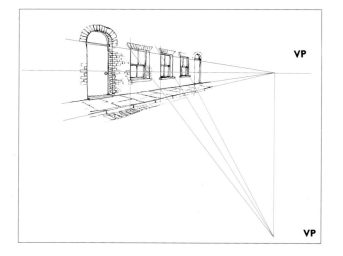

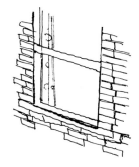

Wrong

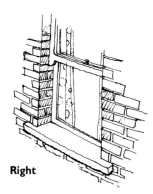

Right

◄ **Calculating depth**
Another common error is miscalculating the spaces between door and windows; remember that these become smaller as they recede. You can work out the distance between things by a system of vertical and diagonal lines, as shown here.

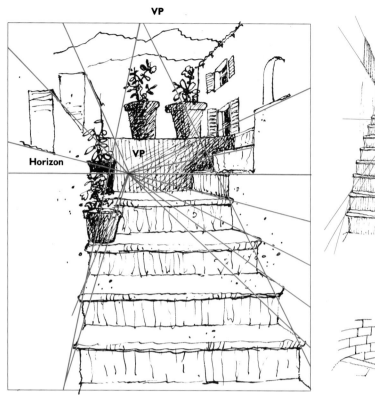

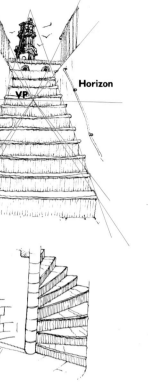

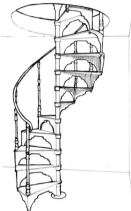

▲ Steps and stairs

These are not as difficult as you might think provided you remember some basic rules. The most important is that a straight staircase is basically wedge shaped, and the top is an inclined plane, so the vanishing point for the sides follows the rules explained on page 21. When marking in the receding lines for the sides try to imagine the staircase covered with a large piece of board, which will simplify the issue. The individual treads, however, are not inclined, so they will have their own vanishing point, lower than that for the sides. As the staircase recedes upwards you will see less and less of the top surface of each step, which is clearly visible when it is below your eye level.

top and bottom, or the side of a balcony or protruding windowsill.

Because these lines are small in comparison with those of roofs and walls, they tend to be regarded as unimportant, but in fact it is vital to learn to estimate their direction correctly, as you will see as soon as you begin to paint. If a recess, or side of a windowsill, is in shadow, you will find that you have applied a dark stripe or square of paint which looks quite wrong, because its shape does not describe the structure. Such mistakes can often be corrected, but it is obviously better to get them right first time.

Estimating spaces

Another common mistake in depicting windows and doors arises from a failure to understand that just as all objects appear to decrease in size as they recede, so do the spaces between them. The further away the windows are, the less wall will be visible between them, and you will see more of the side recess and less of the window front. The pencil or ruler measuring method described on page 18 is a great help here, and it is also a good idea to count the windows first and make rough marks apportioning the position of each one. This sounds obvious, but it is surprising how many people ignore the simple solutions.

▲ Spiral staircases

The important thing to remember about these is that the steps themselves do not curve, but they do taper, so you cannot follow the usual rules of receding parallels. Since there are so many vanishing points involved here, all you can really do is rely on observations.

25

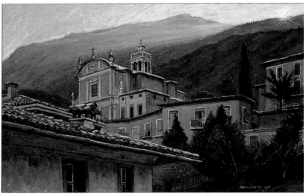

▲ **Venetian Mural** Douglas Lew, *watercolour*
In this fresh and freely painted composition the perspective of the arches and windows is described almost entirely by means of accurately placed shadows.

▲ **Sunrise over Malcesine, Lake Garda** Stephen Crowther, *oil*
The correct perspective of details such as the windows, the arches of the belfry and, most important of all, the deep overhang of the foreground roof were vital to this powerful composition.

▶ **Casa Speranza** Martin Taylor, *watercolour and body colour*
The walls are given additional solidity by the depth of the window and door recesses, a good illustration of the importance of correct perspective in architectural details.

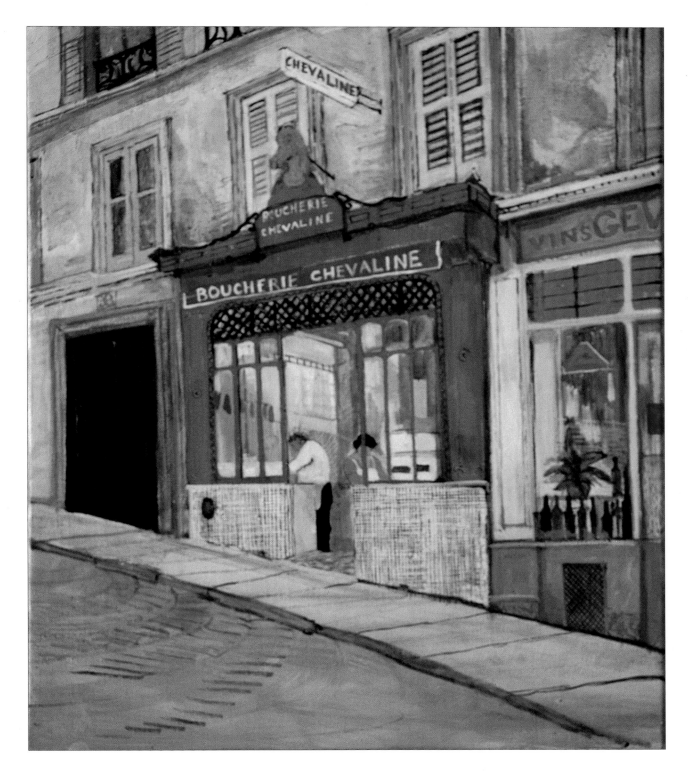

▲ **Boucherie Chevaline**
Richard Beer, *oil*
Perspective is particularly crucial for a close-up study like this one; an incorrectly placed line on the shuttered windows or balconies would make the whole painting look wrong.

CURVES AND ELLIPSES

How do I draw curves in correct perspective?

Curves often give trouble, making it difficult to cope with painting bridges, for example – one of the most rewarding of all architectural subjects. There are plenty of arches in other types of building too, such as churches and atmospheric Classical ruins, and even some quite unpretentious houses have arched door and windows.

But fortunately, the rules of perspective apply just as much to curves as to straight lines, and there is a simple trick

VP **Horizon**

▶ Arches
One of the commonest causes of failure is underestimating the depth. If your drawing or painting looks wrong, draw a box shape over it as shown here.

▶ Bridges
Begin by marking in the horizon line and the perspective lines for top and bottom. Draw each arch first as a rectangle, and then find the centres by the crossing diagonals method illustrated.

▲ Arched windows
You can use the same system of plotting lines for multiple arches like these, but don't become too reliant on them. Careful observation is also needed to see how one kind of arch differs from another. This one is more pointed than the others on this page.

Centre **Horizon**

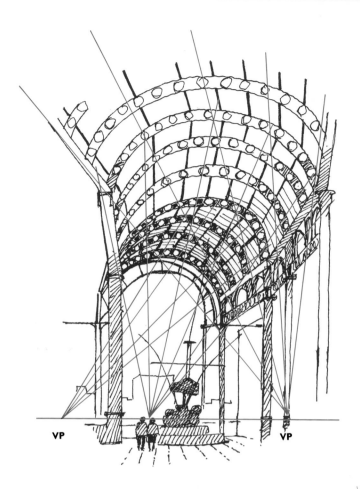

VP VP

▲ Curving sections
For a complex subject like this, in which the curves change direction in the middle, it is best to establish the vanishing points for the straight lines first.

▼ Ellipses
Anyone can draw a circle straight on, since all you need is a pair of compasses, but ellipses can be very bewildering. However, perspective once again comes to the rescue; it is quite easy once you know that all circles fit into squares, just as arches fit into rectangles. Draw the square in perspective first and then simply fit the ellipse into it.

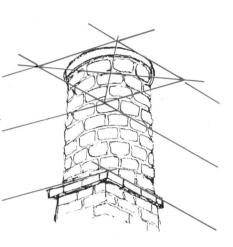

▲ Chimneypots
If you are doing a drawing or painting of rooftops, a wrong ellipse on the top of a chimneypot can ruin the effect. Even when you can't see the other side of the ellipse it is helpful to draw it in lightly as a double check.

for getting them right, shown in the drawing here. Once you realize that each arch fits neatly into a rectangle you will find the task much easier, but do not forget that if you are taking a steep perspective view, showing a good deal of the inside of the arch, the lines of bricks or stones will follow their own separate vanishing point. It is possible to go badly wrong here and make them slope too steeply, so I suggest that you lightly rule in a few guidelines, ensuring that the lines on the horizon are truly horizontal.

Circles and cylinders

These are less common in buildings than arches, but they occur in the form of domes, columns and chimney pots, which can all be equally hard to draw. A circle seen in

perspective, called an ellipse, follows much the same rule as an arch, but in this case it fits into a square rather than a rectangle, as shown in the drawing. It is important to get this right, because if an ellipse at the top or bottom of a chimneypot or column is wrong it will not convey the impression of a cylinder.

It is not a bad idea to practise this kind of measured, geometric drawing for a day or so as it will help you to understand the basic rules. But you certainly won't have to go on drawing squares and rectangles for ever. As always, once you have grasped the principle everything becomes much easier.

29

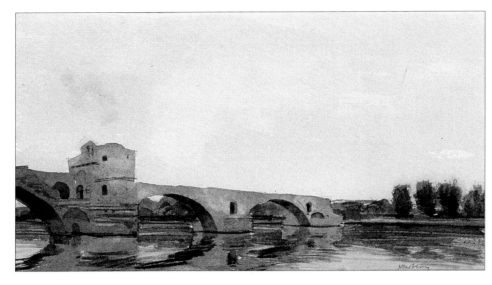

▲ Pont d'Avignon John
Newberry, *watercolour*
Bridges are one of the most
delightful of all subjects,
particularly when the water is
still enough to reflect the arches,
as here. The artist has chosen a
viewpoint which creates a strong
diagonal line across the picture.
He has wisely left the large sky
area almost flat so that it does
not steal attention from the
lovely old bridge.

**▶ St Paul's and Southwark
Bridge** John Lidzey, *watercolour
and conté crayon*
This strong composition is based
on the contrast between the
curves and the crisp vertical and
horizontal lines. The artist
worked from a photograph, but
he was aware that it might not
provide all the reference he
needed, so he backed it up with
on-the-spot colour notes and
sketches. The watercolour has
been used wet in wet, while the
light crayon lines, broken up by
the grain of the paper, add a
linearity and strength in keeping
with the subject.

◀ Randall Street, London
Sandra Walker, *watercolour*
This succession of shallow arches
in a gently curving wall, bisected
by verticals, makes a pleasing
composition. Notice how
carefully the artist has painted
the bricks at the tops of the
left-hand arches to stress the
slight differences in their shapes.

ART SCHOOL

· ·

USING A DRAWING FRAME

Making a drawing frame

There are various ways of making a frame, but in this case button thread is used. You will need white board, a Stanley knife, scalpel or craft knife, a metal straight edge, a ruler and pencil, heavy black thread and a needle of a suitable size.

There is a prevalent belief that drawing is a natural gift – you either have it or you don't. This is nonsense; you may never be able to draw like Leonardo or Rembrandt, but you can learn to reproduce what you see accurately. In the past, artists took a more realistic approach to the subject. They admitted that drawing was difficult, particularly where perspective was involved, and they invented a great many clever devices to help them to get it right. One of these was the drawing frame or drawing grid, a Renaissance invention which the great 16th-century artist Albrecht Dürer used and recommended in his book *The Art of Measurement*.

1 Mark out a rectangle measuring 200 × 120 mm and then draw another one 5 mm outside this.

2 Cut out the inner rectangle.

3 Make marks at 20 mm intervals along each side of the pencil lines, and then "drill" them with the needle.

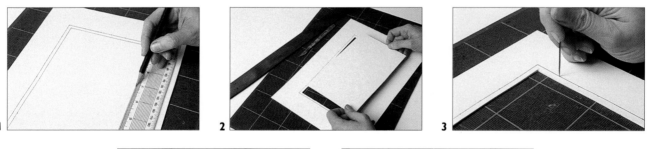

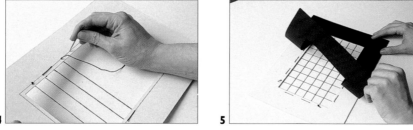

4 Make a substantial knot in the end of the thread. Starting at top left, pass the needle through to the back and then take the thread down to the back of the opposite hole. Bring it through to the front, take it along to the next hole and thread through to the back again. Continue in the same way, ending with a knot at bottom right.

These frames remained in use until at least the 18th century, but have unfortunately now gone out of favour. The current watchword is "spontaneity", and the so-called mechanical drawing aids are frowned upon in some circles. I personally find this an unhelpful attitude. Learning to draw is not a spontaneous process; it is one of training the eye, and to this end drawing frames, like the measuring methods mentioned on page 18, can help you. You will have to make your own frame, as shown in the illustrations, but it is not difficult.

5 When the threading is complete, cut out a piece of black paper to the same size as the frame and glue it on top. This is not essential, but the black makes viewing easier.

Using the frame

Begin by drawing something indoors. Choose an object or group of objects that you can put on a table – a small still life of books, a tissue box and a cup would be a good start – and stand the frame up between you and the subject, supporting it on pieces of Blu-tack or plasticine to make sure it remains vertical.

Mark on your paper the same number of squares as are on the grid and then position yourself so that you can draw sight size, that is, so that the edges of the paper correspond exactly to the edges of the subject. The board should also be vertical, or you will have to translate a vertical image to an angled surface, which can lead to problems.

Close one eye; look at your subject carefully, and begin to transfer each piece of information from one grid to the other, checking where the angles or curves of the objects intersect with the verticals and horizontals of the frame.

The finished drawing may look stiff and stilted, but this does not matter, as it is only an exercise. You might take it further by doing another drawing without the frame – still working sight size – but holding the frame in position periodically to check whether the perspective is right.

Altered viewpoints

The drawing frame also provides a useful means of illustrating the way in which perspective changes as soon as you move your viewpoint, however slightly. Try angling the frame, or yourself, and you will see that the lines of the subject intersect those of the frame in quite different places. It is important to remember this when drawing on location, whether you are using the frame or not. If you are, hold it up at arm's length directly in front of you with your non-drawing hand and *do not move it*. Do not try to complete the drawing in this way or you will become tired and uncomfortable – make sure the main lines are right and finish freehand. If you have an easel you could use this for the frame and have it in front of you, but there is not always enough space for such luxuries.

Select a suitable corner such as this, which has plenty of perspective lines, and prop up the frame in front of your drawing board with Blutack or plasticine. Make sure it is really vertical. Begin to draw, checking where each line or angle intersects one of the lines of the frame.

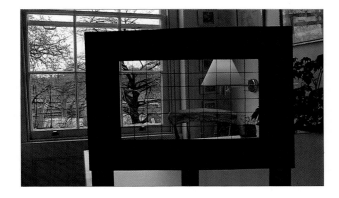

Try to move your head as little as possible – you will notice that as soon as you shift, the perspective will alter.

It does not matter if the completed drawing looks a little mechanical: this is primarily an exercise.

Q & A
SHADOWS

Are there any useful rules for depicting shadows?

Yes indeed there are: shadows are cast by specific objects and follow basic rules, just as objects do. It is important to know how to paint them correctly, as they can play a vital role in composition. A dramatic shadow pattern thrown by a tall building, a group of chimneypots or a fretted trellis can often be more exciting and descriptive than the object itself.

A cast shadow is caused by an obstacle in the path of the sun's rays, which are thought of as parallel, but strike the ground obliquely. Thus both the length and direction of shadows are affected by the position of the sun. At midday, for example, there are virtually no cast shadows because the sun is directly overhead. If the sun is parallel to the picture plane, that is, directly to your left or right, the shadow cast on a level surface will also be parallel, and wherever the sun is, the shadow will always run in the opposite direction.

Sun and shade

The fact that the shape of shadows is dictated by the direction of the sun seems almost too obvious to be worth stating, but it is surprising how people forget the obvious when they are painting. The problem is that when you are working out of doors the shadows change very fast, so it is useful to understand the rules.

◀ ▼ Learning the rules

These drawings show three dramatically different shadow effects. Notice that although the shadows themselves vary they all share the same vanishing points as the houses, an important point to remember. Shadows are not always as straight and perfect as this, of course, because the ground is seldom completely flat, so you will have to observe the way in which they are distorted by swells, dips and broken ground.

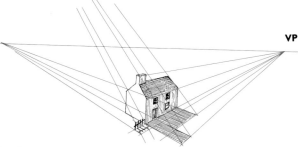

Position of sun

VP

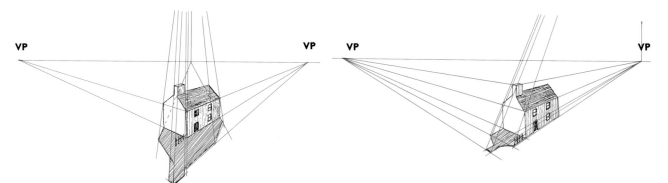

Position of sun

VP VP VP

Position of sun

VP

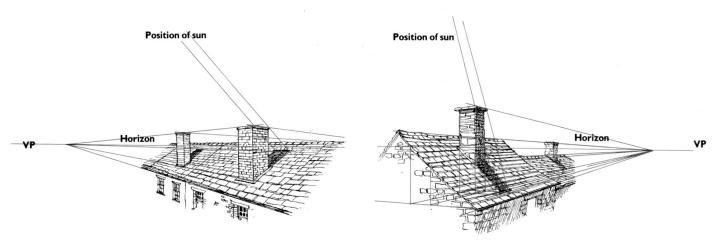

Position of sun

Position of sun

VP **Horizon**

Horizon **VP**

▲ **Shadows on declined planes**

A shadow sloping uphill is always shorter than one on a level plane, whatever the direction of the sun.

When the sun is not on the picture plane – if it is at an angle either behind or in front of you – the shadow will slope towards or away from you. The diagrams show how you can establish the shape and direction of a shadow by following the same laws of perspective that apply to the objects. It helps to understand these principles because shadows can change so quickly. If you are painting on location, you are more than likely to try to catch up with the movement of the sun by altering the shadows from hour to hour, which is why so many people have trouble with them. If you are working up a composition at home from sketches, you can reconstruct shadows "from the book", but for on-the-spot work the best course is to block them in immediately and stick to what you first saw. Some artists make a pencil mark indicating the direction of the light before they do anything else, because if your painting is to feature sun and shade they must relate correctly to one another.

▲ **Shadows on inclined planes**

Shadows which slope downhill are considerably longer, and can make an exciting compositional element in a painting.

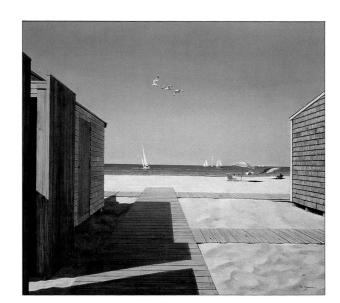

◀ **Nantucket Front, August** Walter Garver, *oil*
If you intend to make shadows a feature, it is important to choose a time of day when they make strong shapes and an attractive pattern of light and dark. The sun in this case would be somewhere on the left behind the artist, providing strong diagonals which complement the rectangles on the right-hand side of the foreground.

35

············ Q & A ············

REFLECTIONS IN WATER

··

How do I paint reflections of buildings?

A great many people go wrong with reflections in water, but in fact the laws that they obey are quite simple. Reflections are an upside-down world, and follow exactly the same laws of perspective as the object reflected, whether it be a building, a bridge or a boat. At least, they would do so if water always provided a completely flat, mirror-like surface. But it seldom does this, and as soon as water is disturbed it becomes not one flat plane but a series of angled surfaces. These confuse and break up the reflection, often throwing one part of it sideways or downwards so that the shape becomes ambiguous and hard to assess.

Basic principles

Returning for a moment to the hypothetical flat water, the most important thing to remember is that a reflection extends exactly as far below the water as the object does above it, and the receding parallel lines will converge at the same vanishing point. So far, so good, but there is a potential pitfall here: the line where the reflection begins is not

▼ **A mirror image**

A reflection in still water is the same height as that which is casting the reflection. However, there is one minor pitfall here. The vanishing point for the reflection is, of course, dictated by the horizon line, and this is not always where land and water meet. The horizon here is half-way up the building, so the roofline of the reflection slopes up to the vanishing point more sharply than the roofline of the building slopes down.

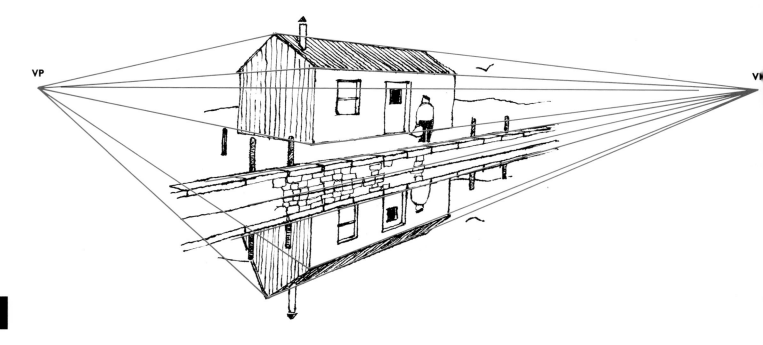

VP

VP

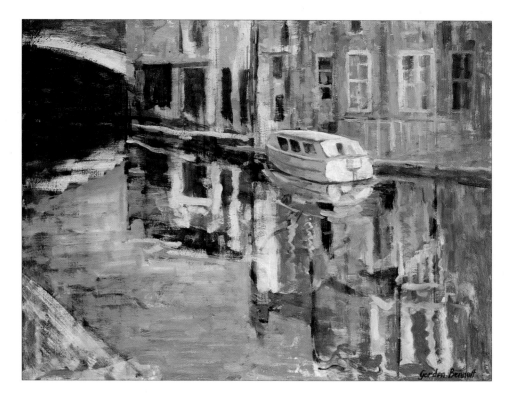

◄ Regent's Park Canal
Gordon Bennett, *oil*
Reflections are a favourite theme for this artist, and one he returns to frequently. He has used a wide variety of colours in the foreground water, and applied his paint freely and descriptively, making curved, straight and squiggly brushstrokes, and allowing one colour to show through another.

► Optical tricks
An interesting departure from the rule is that an object leaning towards you makes a reflection that is longer than itself. In A and B the reflection is equal to the post because it is leaning to one side (A) and straight (B). In both C and D, however, it is longer. In C the post is leaning forwards, while in D it is leaning both forwards and sideways.

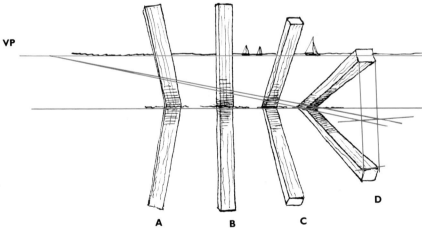

necessarily the horizon line. If the horizon is higher, the parallels of the reflection will slope at a sharper angle than those of the building itself (see drawing). This gives the impression that the reflection is smaller, but in terms of perspective it is the same size.

These rules apply however near or far you are from your subject. The only difference that distance makes is that the further away you are, the clearer the reflections will appear. This is because the water itself is reflecting more light. If you are really close, you will not be able to see reflections at all; the water will lack any mirror properties.

Disturbed reflections

Agitated water is a complex subject, and it is only possible to provide the most general of guidelines for the way it affects reflections. Each ripple of wavelet has a convex and concave surface, which reflect objects at different angles, producing an effect of irregular stripes or blobs. Reflections in ripples, which can be an exciting part of a composition, are best tackled by observation and on-the-spot work. You can use photographs as reference, but a series of quick line or wash sketches will teach you more, because drawing forces you to think and analyse shapes.

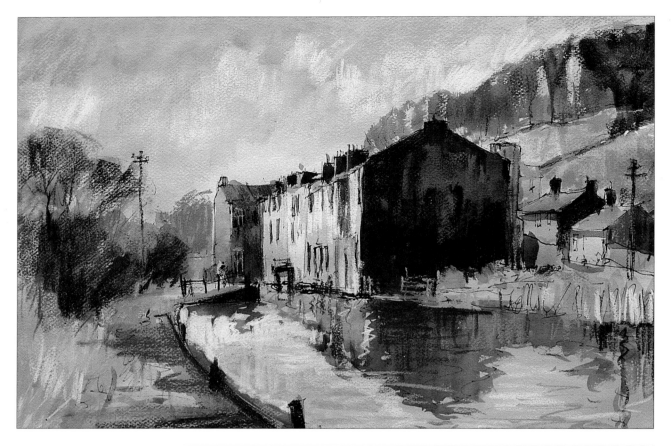

▲ Canal at Farnhill John Tookey, *pastel, watercolour and pen and ink*
Reflections, like shadows, can be used to create a stronger and more interesting composition. In this mixed-media painting the slightly ruffled water with its delicate pattern of ripples makes a pleasing contrast to the solidness of the row of houses. The reflections were initially laid in with watercolour, and light strokes of pastel were added on top. Pen and ink lines on the houses provide touches of crisp definition.

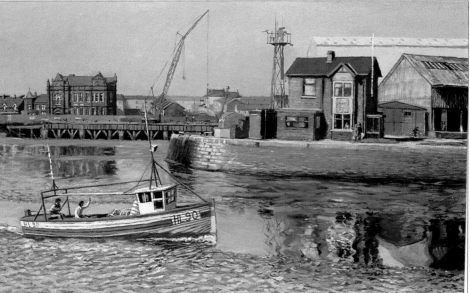

▲ Seaward Bound Stephen Crowther, *oil*
Notice that the reflections of the houses, although distorted by the slight movement of the water, are exactly the same height as the buildings themselves. The artist has used them as a powerful compositional device; without them, particularly those on the right, the picture would be unbalanced.

▶ **Shepperton Manor** John Plumb, *oil*
Reflections in moving water are endlessly fascinating, as the patterns they make change rapidly. Here the reflection of the house makes a more exciting shape than it would in completely still water, giving a feeling of movement to an otherwise static subject.

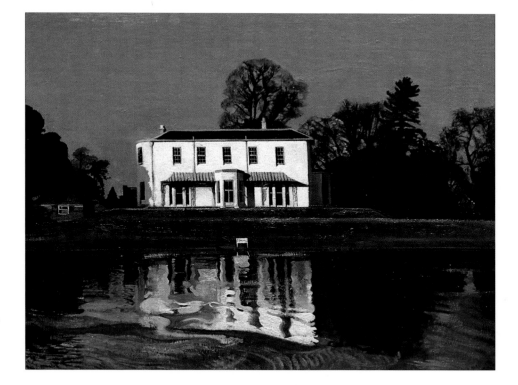

▼ **Reflections at Ockham**
John Plumb, *pastel*
It is a bold move to paint the reflections without the objects reflected, but in this case totally successful. Although the reflections are distorted, they provide a surprisingly accurate description of the buildings.

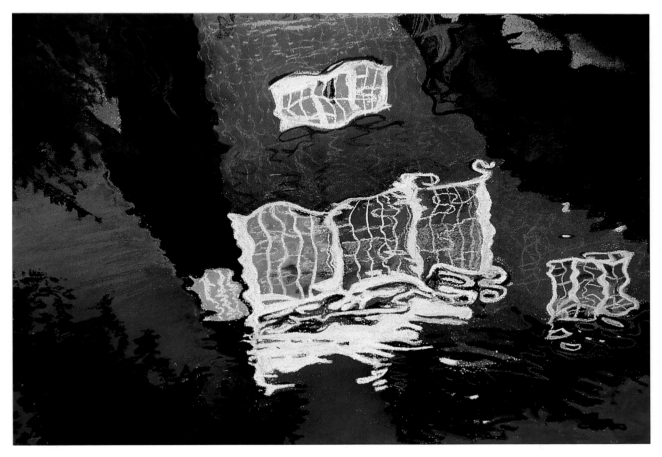

······· Q & A ·········

BUILDINGS IN PROPORTION

·································

Is there a way of getting the proportions correct?

This is one of the most important aspects of painting buildings, just as it is in designing them. If you misrepresent the proportions of an architect-designed building you will convey neither its beauty nor its character. And even if your subject is an unpretentious barn, farmhouse, village store or town house, in which no architect has had a hand, you will want it to look like a specific building, not just a box with a roof on top and some windows. It is really very much like painting portraits – you will not achieve a likeness unless you get the features right. Moreover, if the features, in this case the doors and windows, are too small or too large in relation to the wall area, the building will look unbalanced or even structurally impossible.

Make a measured drawing

Once you have realized the importance of proportion the rest is simply a matter of looking closely, taking your time, and using the measuring method explained on page 18. In this case, I suggest you use a ruler rather than a pencil, as measurements need to be as precise as possible. Always begin mapping out the main shape by measuring how many times the height goes into the width or vice versa, or how

Correct proportion is just as important as correct perspective, so always take careful measurements before starting to paint.

▼ **Drawing sight size**
If you are not practised at drawing it can be very difficult to "translate" a large subject into a small drawing. There is a tendency for measurements to go awry, however careful you think you are being. It is easier to work sight-size, as shown in the illustration. Support the board on an easel if possible so that it is vertical, not sloping, and have it low enough for you to see over the top. Shut one eye and tick off the widths of the walls, windows and so on along the top of the paper. This will provide a frame of reference for the heights, which you can measure by holding up a pencil – make sure you hold it on the same plane as the board.

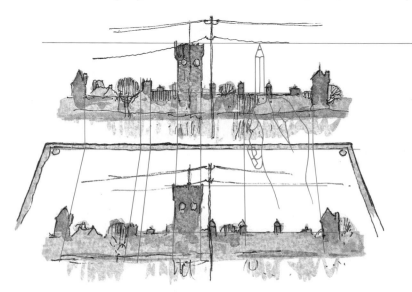

much of the total wall area is occupied by a porch or central pediment. And if there is a feature of this kind, make sure that it really is central; find the middle of the building by drawing diagonals, as shown on page 24.

To judge the exact height of a window or door, use the ruler again, and do the same for the spaces between windows. It is easy to forget about spaces, but if you are drawing a multi-storeyed house they are as important as the windows themselves, if not more so. Each window represents a room inside the house, and if you do not leave enough vertical space between them you will give an impression of cramped and highly uncomfortable rooms with impossibly low ceilings.

Scale

Take particular care with doors, as these play a vital role in establishing scale. Windows can vary tremendously in size, from huge picture windows in a modern house to tiny apertures hardly larger than peepholes in some old country cottages. But doors have to be the right height and breadth for a person to pass comfortably through without stooping, and so they are a more-or-less standard size. Artists often include a figure or two in paintings of buildings to point up the size of the structures, but a door can be a substitute for a human figure, providing a key to scale. Of course not all doors are quite so standardized: in cathedrals, palaces and the country homes of the aristocracy they are sometimes large enough for a carriage and horses to drive through, but doors are a useful scale guide to remember when painting ordinary houses.

Bricks and stones

So much for windows and doors. A much easier trap to fall into is failing to assess the size of the bricks, planks or stones that go to make up walls, or the tiles and slates of a roof, or the width of drainpipes and chimneypots. You may not want or need to paint every brick, but even if you are just picking out a few here and there, they must be the right size or your painting will look very odd. Train yourself to measure such details, and if necessary count them. I am not suggesting counting every brick or tile, but it is helpful to know, for instance, how many bricks there are in the area of wall to the side of a door or window, or how many rows of slates on a roof. It is little things like this that make a painting look as though the scene has been observed and truly appreciated, rather than invented.

▲ Wrong
Georgian houses were built according to strict rules of proportion, and this drawing is obviously wrong. The building itself is too squat, the windows too large and the door disproportionately wide.

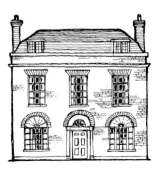

▲ Right
Here the elegance of the architecture comes across clearly. When you are taking measurements of windows and doors don't forget to measure the spaces between them also.

▼ Wrong
This door, also Georgian, is again too short and squat, though it might pass muster among those not well versed in architectural styles.

▼ Right
This one is tall and graceful, as the architect intended.

LEARNING FROM THE
MASTERS
COROT

C orot (1796–1875) was a hugely successful artist, with an enormous output – he is also reputed to be the most forged of all painters. Although he broke no dramatic new ground in art, he brought to his chosen landscape subjects a fresh directness of vision that had not been seen before in French painting. He always adhered to the advice of his teacher Michallon, a historical landscape painter, "to reproduce as scrupulously as possible what I saw in front of me", and he worked out of doors extensively. Much of this on-the-spot work took the form of sketches for large studio works, but he also produced small, less formal pictures like the one shown here.

Corot was greatly admired by the Impressionists, and was sympathetic to their aims although he refused to give them official support. He had a kind and gentle nature – Degas described him as "an angel who smoked a pipe" – and did not enjoy quarrels and hostility. He lived for his work, never married, and at all times did his best to surround himself with the tranquillity so evident in his pictures.

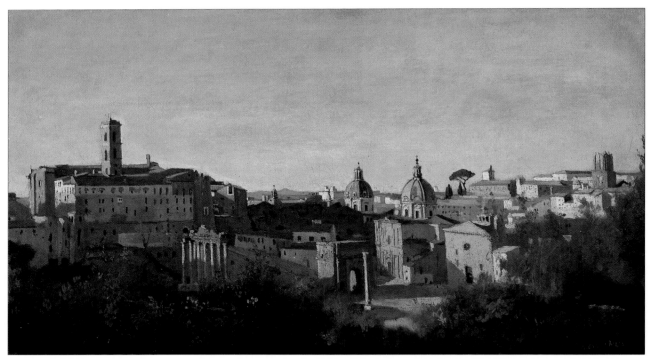

View of the Roman Forum from the Farnese Gardens 1826
Oil on canvas
11 × 19¾ inches (28 × 47.5cm)
Louvre, Paris

This picture was done during Corot's first visit to Italy, and was painted out of doors in spring.

Corot always preferred a distant view of his subject as this allowed him to simplify the forms – a useful practice to follow when painting architecture. In spite of his claims to reproduce reality with faithful exactitude, he would "edit out" any inharmonious elements, and here he has spaced out the domes, reduced their number, and slimmed down the tower on the left.

Limiting the colours

Like many artists from northern countries, Corot was struck by the quality of the Mediterranean light, and for a time despaired of being able to capture it. He realized that the strong sun bleached colours rather than strengthening them, and to achieve this effect he added white to all his pigments. This also helped to unify the composition by providing a common factor which ties all the colours together.

His range of colours was deliberately limited for the same reason, and just as he simplified forms, he would also tone down any hue that seemed to detract from the picture's harmony. He liked to keep the foregrounds vague and understated, as here, where the almost out-of-focus effect leads the eye in to the central group of buildings.

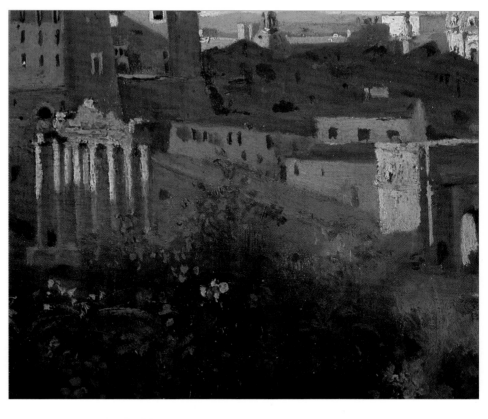

Controlling paint thickness

Corot worked thoughtfully and slowly (this painting took 15 sessions to complete), judging each area of colour and tone with great care. He also gave much attention to the thickness of the paint, an important aspect of oil painting. An acquaintance of his noted that he would cast "an unquiet eye over every part of the canvas before putting a touch in place ... If he makes haste he may become clumsy and rough, leaving here and there inequalities of impasto [thick paint]. These he afterwards removes with a razor." This detail shows how he has used impasto to emphasize the light, bright pinks of the sunstruck areas of the buildings, while the paint for the shadowed parts is much thinner.

ART SCHOOL

· ·

MAKING THE UNDERDRAWING

In this section of the book I have stressed the importance of a careful preliminary drawing, so I shall now provide some practical advice on how to go about this.

Basically, you have a choice of two procedures. The first is to make your drawing on the spot, drawing directly on the canvas or paper that you will use for the painting. The second is to work indoors from a "working drawing", sketch or photograph – either monochrome or coloured – that you have made in advance, transferring it to the painting surface, and enlarging or reducing it as required.

Your choice of procedure will depend on your particular way of working, on the complexity of the subject and on the medium that you have decided to use. If you are painting an uncomplicated subject, such as an old barn or farmhouse set in a landscape, and you are using oils, you will not need a detailed underdrawing, and will usually be able to sketch in the few lines necessary to establish the composition and the placing of the verticals and horizontals immediately before you lay on the colour. However, if you are tackling a complex cityscape with a wealth of intriguing architectural features, you will require a good, solid foundation on which to work or you will find yourself painting hesitantly and uncertainly – a recipe for failure.

Working directly on canvas or board

Charcoal is often recommended for the underdrawing for an oil painting, but for architectural subjects pencil is a better bet, as it enables you to make finer, more precise lines. Either commercially prepared canvas or the various types of painting board that are available will provide good surfaces for pencil drawing, even if they are not quite as sympathetic as paper. Erasing is no problem either, as unwanted pencil lines can be lifted off easily and cleanly. Avoid using too soft a pencil – HB or B are eminently suitable. With a harder pencil you could have difficulty seeing the lines, while a very soft one may mix with the first paint you apply and muddy it. If your finished drawing looks as though it might sully the paint, give it a quick spray of fixative before painting.

Working directly on paper

If you are using either pastel or the water-based paints – watercolour, gouache or a combination of the two – a good drawing is particularly crucial. If an oil painting goes wrong it can be scraped down, and mistakes in an acrylic can be overpainted, but watercolours cannot be changed radically (although small corrections can be made) and neither can pastel.

Making an underdrawing for a watercolour, however, does present certain problems, and you will not notice these difficulties until you start to paint, so be forewarned. One is that the drawn lines will often show through the paint in the lighter areas. This means that the lines must be as light as

◄ Squaring up is the traditional way of enlarging a drawing, and is particularly useful for architectural subjects, where drawing freehand may cause distortions in perspective. Some artists always make their preliminary drawings on ready squared paper to facilitate the process.

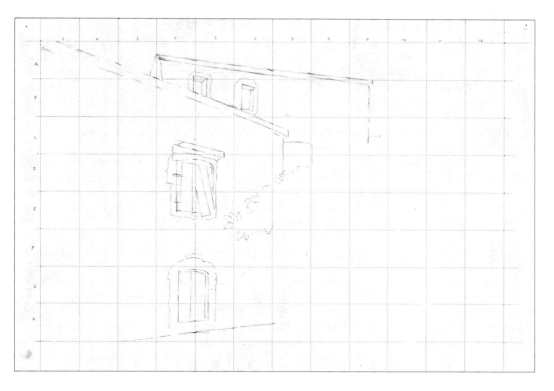

◀ ▲ Another method is to
photograph the drawing on slide
film and project the image
directly onto the working
surface. You will need a tripod-
mounted camera to do this, and
the drawing must be held
exactly on the vertical or the
photographed image will be
crooked.

possible, and should be kept clear of any areas that are to remain white or very pale in tone. If you find pencil lines showing through after you have put on the first washes, let the paint dry and gently rub with a soft eraser – they can usually still be removed at this stage. The second problem relates only to papers that scuff easily when lines are erased, removing the top (sized) layer. This allows the wet paint to sink in, leaving unsightly blotches.

Many watercolour papers can withstand any amount of erasing, but until you have discovered which ones are likely to give problems it is wise to run a test in advance. If you find that the paper you like best has this tendency, be extra careful with erasing, using kneaded putty and a soft pressure. Alternatively, ensure that you have only the minimum of erasing to do by using the transfer method described below.

Underdrawings for pastel can be made either with an ordinary pencil or a pastel pencil. The advantage of the latter is that you can choose a pale colour or one in keeping with the overall colour of the scene so that the initial lines merge with those you apply later.

Transferring a drawing

Sometimes known as squaring up, this is a way of transferring a working drawing or photograph to the painting surface, and the great advantage of this technique is that it allows you to enlarge the original drawing as much as you like (or reduce it, of course). When drawing on location, it is often more convenient to make quite small sketches, and one of these may suggest a larger painting that you can do indoors. If you are using a photograph you will almost certainly need to enlarge it, of course.

Squaring up is a simple process, involving no more than drawing a grid of equal squares over your drawing, another grid with larger squares on your canvas or paper, and then transferring the information from each small square to its larger (or smaller) counterpart. Initially it seems a little laborious, but once you have found out how much erasing can be involved when you try to carry out the same process freehand, you will begin to appreciate it. If you don't want to spoil the original drawing or photo, you can lay a sheet of acetate over it and draw the grid on that.

A quicker method is to use photocopies. Most photo-copying machines are now capable of enlarging an image, so your small sketch can be quickly doubled in size, and doubled again if need be. It can then be transferred to the working surface using the carbon paper that is sold for designers and dressmakers and is available in the majority of art shops. This comes in a variety of colours, and unwanted lines can be erased in the same way as pencil.

JOHN LIDZEY
WATERCOLOR DEMONSTRATION

Lidzey works predominantly in watercolour, sometimes combining it with other media such as conté crayon (an example is shown on page 31). He dislikes the effect of obvious brushstrokes, and works largely wet in wet, controlling the fluid paint with great skill. Most of his finished paintings are done in the studio from on-the-spot sketches, occasionally with photographs as back-up reference.

▼ **1** The painting was based on this colour sketch. Time is often limited when working outdoors directly from the subject, so the artist has made written notes about colours and the types of trees in the background.

▼ **2** Having stretched his paper on a drawing board, important when painting wet in wet, the artist is now ready to make the preliminary drawing. He takes careful measurements with callipers to ensure that this is accurate, and the proportions accord with those of the sketch.

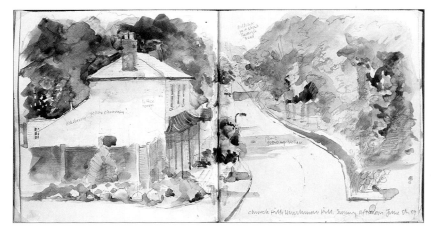

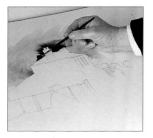

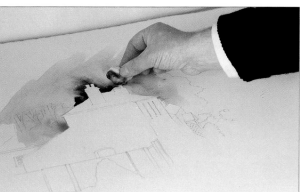

▲ **3** With the pencil drawing completed, he begins by laying a wash on the area behind the roof. Without allowing it to dry, he then drops darker colour into it.

◄ **4** Wet in wet is an unpredictable technique as the colour can spread in ways you did not intend. Here a small piece of cotton wool is used to mop up the excess paint.

► **5** Because the house was to remain basically white, the background and parts of the foreground have been painted first. The fluid paint has been taken very carefully around the edges of roof and walls so that the outlines remain crisp and clean.

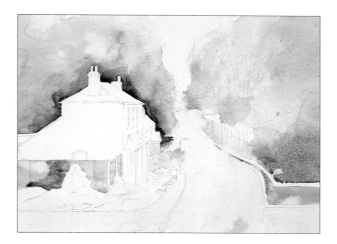

◄ **6** This detail from a later stage of the painting shows how cleverly the wet in wet technique has been exploited to suggest the shapes of the massed foliage.

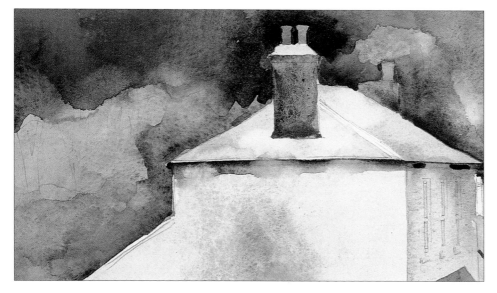

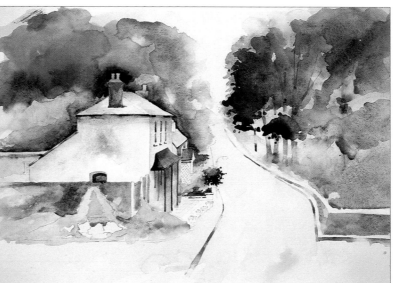

► **7** Lidzey always prefers to work with a limited palette, which gives his paintings an overall unity of colour. Notice how he uses a similar blue on both the house and the trees, with a slightly warmer mauve-blue for the foreground wall.

◀ **7** The contrast between hard and soft edges is one of the most exciting features of good watercolours, so it is not advisable to work wet in wet throughout the painting process. The crisp edges shown here were achieved by dropping a fluid but powerful dark blue mixture onto the now dry green wash, giving an ink-blot effect.

▶ **8** The paint for the group of trees behind the house is still thin enough for the drawing lines to be clearly visible. They can be erased when the paint has dried, but in this case it is not necessary as the artist intends to add darker colours.

◀ **9** This detail of the finished painting shows how he has varied his technique, working wet in wet where he wanted soft effects and wet on dry where clear, precise definition was needed. It is always best to leave small details, such as the fenceposts, windows and balcony here, until last.

▶ **10** The dark purplish-blues and greens allow the chimneypots to stand out with exceptional clarity. The patch of bright yellow on the trees was achieved by spattering slightly opaque paint onto the surface with a bristle brush.

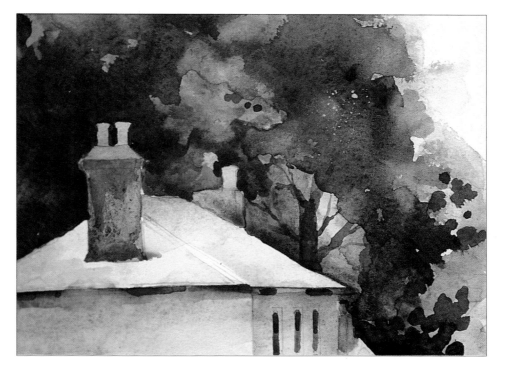

▼ **Church Hill, Winchmore Hill** John Lidzey, *watercolour on stretched paper*

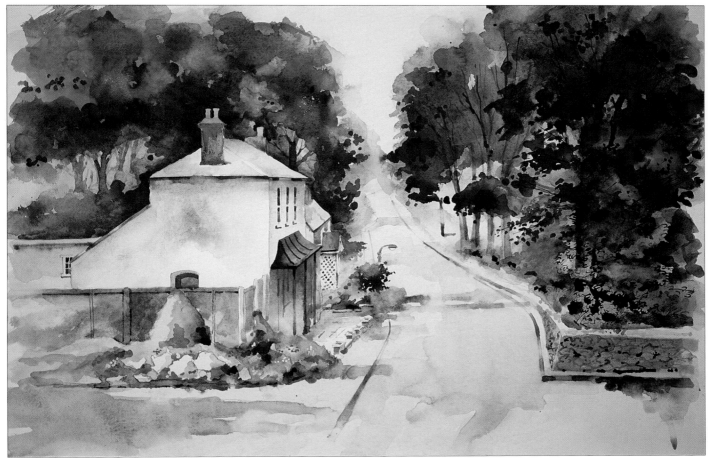

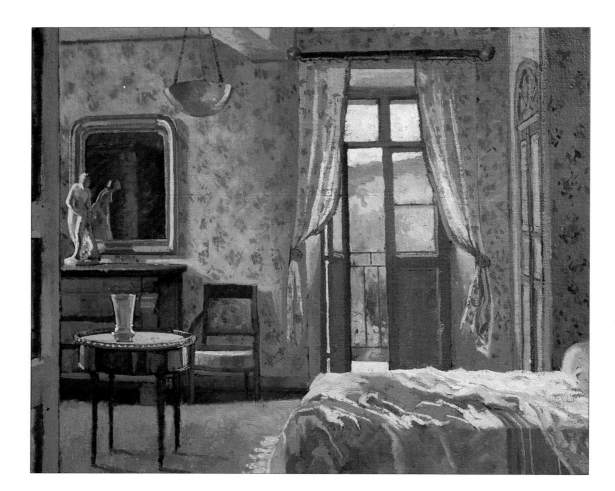

Interior at Les Planes James Horton, *oil*

PART 2

· ·

INTERIORS

· ·

THE INSIDES OF BUILDINGS OFTEN MAKE MORE
EXCITING PAINTINGS THAN THE OUTSIDES – AND YOU
CAN BEGIN EXPLORING SUCH POSSIBILITIES IN YOUR
OWN HOME.

INTERIOR PERSPECTIVE

· ·

Are there any special rules for perspective in interiors?

When you consider the question, it is obvious that the insides of buildings must follow exactly the same rules of perspective as the outsides. However, when you are effectively enclosed by the subject of your painting instead of safely apart from it, the perspective tends to become either less apparent or extraordinarily difficult to assess. For one thing, the main lines will often be interrupted or obscured by other objects, such as chairs and tables, which will very probably have a different vanishing point to that of walls or doors. And secondly, because your viewpoint is so much closer, you will automatically pan around the room, and every time you move your viewpoint, however slightly, the perspective changes.

The field of vision

Just as camera lenses see at specific angles, so do our eyes. Our angle of clear vision, as you can see in the diagram, is fairly limited, but when you are painting a room there is a natural tendency to include objects that are outside or on the edges of your area of vision, because you cannot get far enough away to put everything in. This wide-angle view produces distortions of perspective, which can be used to good effect by experienced artists but are best avoided by beginners. So if you want to get the perspective right, stick to drawing and painting only what you can see clearly without moving your eyes.

Common faults

Paintings of interiors, or even a still life of objects on a table top, often look just that little bit wrong because the perspective is inconsistent. We paint what we think we know, not what we really see, and because we know that a table, shelf or chair is square or rectangular, we tend to exaggerate the depth of the top surface, which results in an uneasy, tip-tilted look. Tiled floors present an even greater hazard, as in this case you have not one but a whole series of receding surfaces, and if you don't get them right the floor will appear to run uphill.

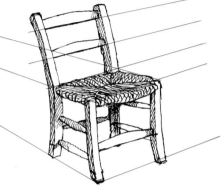

▲ ▼ **Drawing practice**
Coping with the complexities of a whole room can be discouraging, so it's a good idea to start by drawing objects within it. Once you have mastered the perspective of a chair or table you can become more ambitious.

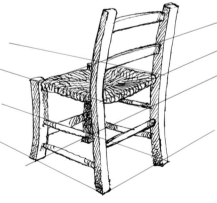

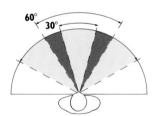

▲ **The field of vision**
Humans have quite a narrow field of clear vision, known as the cone of vision. When drawing interior perspective it is important to include only those things that fall within this cone; you can check this by using the viewfinder illustrated on page 56.

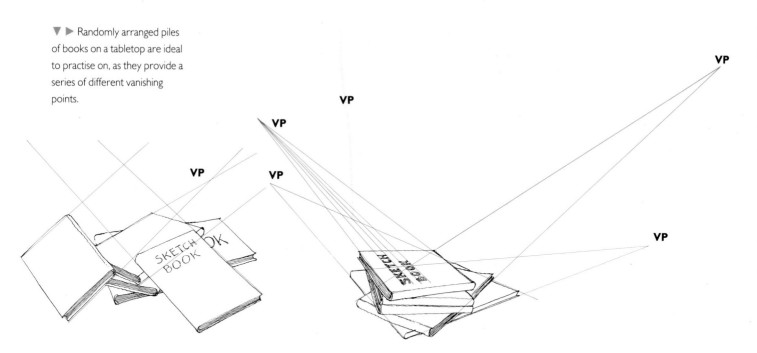

▼ ▶ Randomly arranged piles of books on a tabletop are ideal to practise on, as they provide a series of different vanishing points.

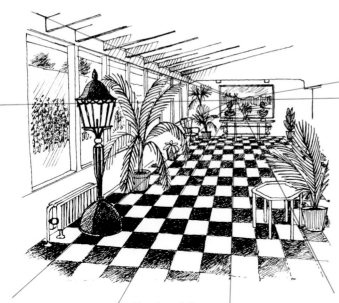

Look and draw

So your first task is rid yourself of preconceptions and begin by analysing your subject. The best way to do this is to sit down and draw. Have a look at the sketches shown here, and set yourself some similar exercises, choosing whatever object in the room you like – a chair, a table, a window frame, an open door or a bookshelf at an angle to you. Make a careful study of it, first from one angle and then from another, holding up a pencil or ruler directly between you and the object and sliding your thumb up and down to measure the proportions or angles.

◀ Tiled floors are always tricky, but not impossible if you mark in the vanishing point first (in this case it is approximately in the middle of the picture on the wall). Don't be afraid to use a ruler, at least for the first row of tiles.

▶ A combination of circles and straight lines always makes a lively composition. Turn back to page 30 for advice on circles and ellipses.

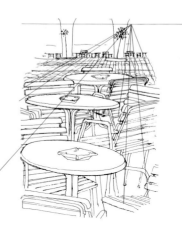

When you are drawing as part of a learning process, it is easiest to work sight size, using a drawing frame as explained on page 32. This enables you to transfer the measurements directly to the paper. If you draw smaller or larger than this you will have to work entirely by comparing each new measurement with the first one, a laborious process as well as a less accurate one. If you have made a drawing frame you will find it very helpful in this context, but don't become too reliant on it or you may stop looking at things properly. And never be afraid to use a ruler to draw straight lines, at least initially.

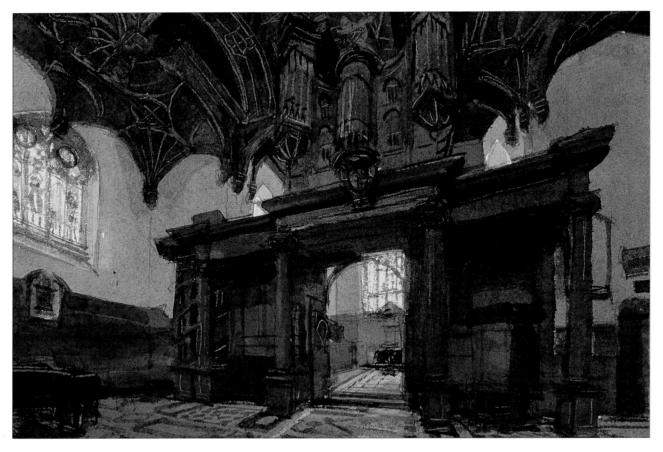

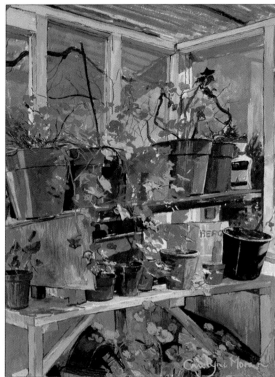

◀ A Corner of the Conservatory Carolyne Moran, *gouache*
Knowledge of perspective has allowed the artist to contrast clean, straight lines with the crooked and sagging shelves which bear the plant pots.

▲ Brasenose Chapel, Oxford John Newberry, *watercolour*
For paintings such as this (top), the artist prepares a careful drawing (above) and transfers it to his painting paper by photostatting.

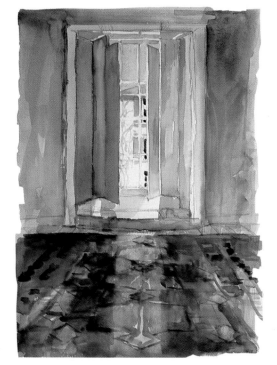

▼ Spitalfields Market

Trevor Chamberlain, *oil*
The paint has been applied loosely and freely, but the perspective of roof, arches and columns is completely convincing, with the receding lines creating a sense of size and spaciousness.

▶ Interior with Turkish Carpet Jane Corsellis, *watercolour*

Perspective can be a valuable compositional tool, as here, where the converging lines of the foreground carpet lead the eye towards the focal point of the picture.

PAINTING THE FAMILIAR

How can I make an interesting painting of my own home?

Although an increasing number of today's artists are finding inspiration in domestic interiors, usually their own homes, the subject is a less popular one with amateurs. To some extent this is related to the drawing difficulties mentioned on the preceding pages, but there is also a feeling that one's own home is inadequate in some way. It doesn't have large enough windows or lovely sea views; it doesn't catch the morning or evening light; the walls need repainting, and so on. Altogether, you can't see it as a proper subject for boasting about in paint.

What you are actually doing, of course, is rejecting a perfectly good subject because it is too familiar. You must rid yourself of this feeling, however, because for the artist, familiarity does not breed contempt and boredom, but affection and understanding – at least in visual matters.

Choosing the subject

So how do you go about sparking your imagination? Interiors are a more amorphous subject than exteriors, presenting a wider range of decisions, so it may help you to consider interior painting as a branch of still life. The only real difference between the two is that still life shows a group of objects in the setting of a room, while here the subject is the room itself. Use a viewfinder (see illustrations) to isolate various aspects of the room, and then make some small pencil, charcoal or ink sketches to check which one makes the best composition. In general, it is best to avoid a direct front-on view of one wall because this will give you only a set of horizontal and vertical lines, which can make the picture look very static. Try to choose an oblique viewpoint – a corner, for example – as this will give you some diagonals as well, and these help to create a livelier effect.

The centre of interest

Nearly all paintings have a centre of interest, or focal point. Abstract compositions, often more concerned with colour, texture and juxtaposition of shapes, convey a different kind of visual message and sometimes (not always) dispense with

▲ **Making a viewfinder**
You can use your hands as a makeshift viewfinder by making a box with your fingers, but a cardboard one is more satisfactory. All you have to do is cut a rectangle in a piece of cardboard – black, white or a neutral colour. A good size is about 7.5 × 5cm (3 × 2 inches).

▲ **Using a viewfinder**
Keep the viewfinder handy so that you can use it whenever you see a likely subject. Hold it up at arm's length and move it around so that you can isolate various areas and choose the most promising composition.

focal points, but a good representational painting must involve its audience, and the focal point is a way of bringing the viewer into the picture.

When you are painting interiors, it is easier to decide on a focal point than it is when you are painting a landscape. In the latter case, you will often have to invent one, but an interior is likely to have a built-in centre of interest, such as a well-proportioned window or mantelpiece, so the focal point will usually arise naturally from the way you have chosen and perceived your subject matter.

But even when you know what your focal point is, you will still need to consider where to put it. The golden rule is anywhere but slap in the middle. To centre it would reduce its impact rather than heightening it, as symmetry is monotonous, and acts as a sort of block to the eye. Think of the rest of the picture as a series of pathways or signposts to the focal point, and try to plan a composition which has some diagonal lines leading in and balancing the verticals that any interior scene provides.

Once you have established the nature and position of the focal point, you may find that it needs some further emphasis if it is to proclaim itself as your main theme. One way of giving it extra strength is to make use of a contrast of tones, reserving the lightest and darkest ones for the focal point – the eye is immediately caught by contrasts of this kind. Another method is to use the brightest colours as an eyecatcher, while yet another is to paint the texture in greater detail in this area. But do not emphasize the focal point so much that you isolate it; remember that all the elements in a painting must work together in harmony.

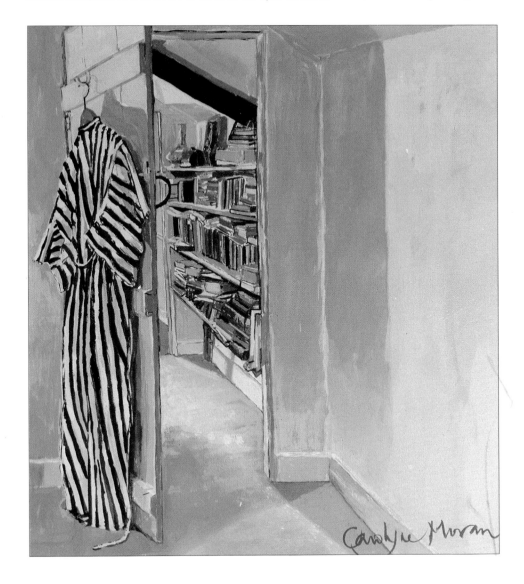

◀ **The Striped Kimono**

Carolyne Moran, *gouache*

Once you have learned to look at your surroundings with an artist's eye you will begin to see possibilities in the most mundane subjects. Taking the striped gown as her starting point the artist has skilfully built up a composition that, although almost monochromatic, has considerable power and vitality. Open doors are always intriguing, as they draw the viewer into the picture, but this one serves an additional pictorial purpose: the striped effect of the books acts as a counterbalance to the gown.

LEARNING FROM THE
MASTERS

BONNARD

he paintings of Pierre Bonnard (1867–1947) are essential viewing for anyone interested in representing interiors; he is the prime example of an artist who made visual poetry out of his immediate surroundings. He and his close friend Edouard Vuillard took the Impressionist tradition a step further in their lovely depictions of domestic interiors to develop a kind of painting known as "intimisme". His work was popular in his lifetime, as it has been ever since. Although he was an innovator, he never offended public taste as his wilder contemporaries often did, and his life was as quiet and uneventful as his pictures are colourful and exuberant.

Bonnard began his artistic career as a graphic artist, and much of his understanding of colour manipulation came from the discipline of lithography. As he said himself, "when one has to establish relations between tones by ringing the changes on only four or five colours, superimposed or juxtaposed, one makes a host of discoveries."

Interestingly, he did not paint from life and rarely made colour sketches; his approach was intuitive, his equipment extremely limited, and his working methods unconventional. He had no easel, and would paint in any available room, sometimes with canvas tacked to the wall with drawing pins, and he would often change the format of a picture halfway through by cutting off or adding a strip of canvas.

Colour echoes

This detail shows both the variety of colours used in each area and the closeness of their relationship. Small, brilliant touches of the rose pink used for the dress reappear among the reds, greens and yellows of the wallpaper, while hints of yellow-green can be seen in the dress itself. The paint was worked wet into wet to create the soft effect, and the scraping down technique was also used in places.

Scraping down

Bonnard built up his pictures in thin layers of paint, often scraping one down with a palette knife before applying another. This resulted in the delicate colour-veil effect you can see on the cup and saucer and the area of red cloth below it. The right side of the jug was also built up and scraped, and this makes a much softer outline than that on the left, where thick paint has been applied over thin to indicate the main fall of light. The body of the jug was painted in violet, overpainted in black and then scraped.

Interior at Antibes 1920

Oil on canvas
46 × 47½ inches (116.8 × 120.6cm)
Tate Gallery, London

Bonnard seldom used more than about eight colours, and because he repeated them in varying amounts all over the picture his paintings have a marvellous unity as well as brilliance of colour.

The paint is applied fairly thinly in most places, but the variety of techniques adds an extra dimension of surface interest. The patterned areas of wall on the left and right were achieved by working small dabs of bright red into still-wet strokes of yellow and green, while other brushstrokes, such as those on the table and the dress, follow the direction of the shapes. Bonnard has prevented the figure from becoming the centre of interest by placing it to one side and treating even the face quite broadly. Notice also the cat, which plays a part in the composition but is "held down" by the very sketchy treatment and the repetition of the colours used for the floor.

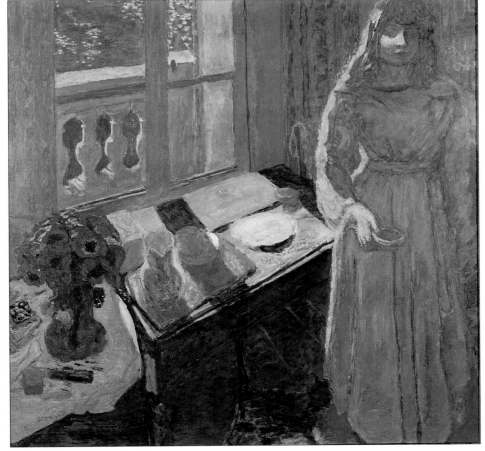

NATURAL LIGHT

. .

Is there a way of coping with changing light?

Without light, nothing exists; it is the quality of the light that governs our perceptions.

This can be a problem whenever you are painting directly from the subject, but it is particularly noticeable indoors. The levels of natural light in a room vary considerably according to the weather and the time of day, and if the room is one that lets in the sun the problems are compounded by shifting patterns of light and shade that change the colours and tones from one hour – sometimes even one minute – to the next.

But light *is* what we see; without it nothing can exist in terms of form, shape and colour, so you must think of it as an integral part of the room rather than a sort of optional extra. It is the particular quality of the light that governs how we perceive a subject. Thus if you have seen a potential subject for a painting, such as rumpled bedclothes catching the morning sun or a pattern of shadows cast by window bars on a table or floor, it is pointless setting up your easel later the same day when the sun has moved round – your subject will no longer be there.

Planning work sessions

You will have to work quickly and decisively. This does not mean you must drive yourself to complete a whole painting in an hour or so – although if you naturally work fast you may be able to – but that you must plan a series of work sessions on successive days. All the artists who paint interiors – and, of course, still lifes lit by an outside light source – work in this way, sometimes having two or three paintings on the go at the same time. Learn to be tough with yourself; when a painting is progressing well it is always tempting to continue for as long as possible, but if you do this you will unconsciously start to alter the colours and tones to keep up with the changing light, and this will result in a confused painting.

Reference sketches

If you are naturally a slow worker, and are planning an ambitious painting, you may find it easier to make a series of small, quick colour sketches at the same time each day.

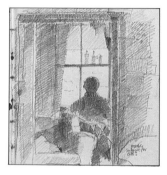

▲ Observation
Quick pencil sketches like this one will help you to observe the behaviour of light, and can often form the basis for a later painting.

These can then form the basis of a larger picture, which you can work on at your leisure. This may be more satisfactory for the amateur, who might only have one whole day a week set aside for painting but who might be able to spare half an hour or so each day to make sketches. There is some advice on page 64 on how to go about this in such a way that the minimum of time need be devoted to drawing.

In general, it is not a good idea to work from photographs. The camera is not very reliable when it comes to indoor light, particularly if there is a high degree of contrast of light and shade. You will probably find that the shadows are reduced to bars of solid black or dark brown, and the patches of sunlight that you liked so much are bleached to an unpleasant blue white. You can, however, use photographs in combination with sketches, and they are certainly useful as reference for hard-to-draw details, such as furniture.

▶ **Girl in Mirror** Jane Corsellis, *oil*
A lovely, intricate pattern is created by the light filtering through the blinds and reflected in the mirror. The muted colours enhance the effect, imparting a silvery glow to the picture, and the doorway creates a frame within a frame to heighten the activity within the room.

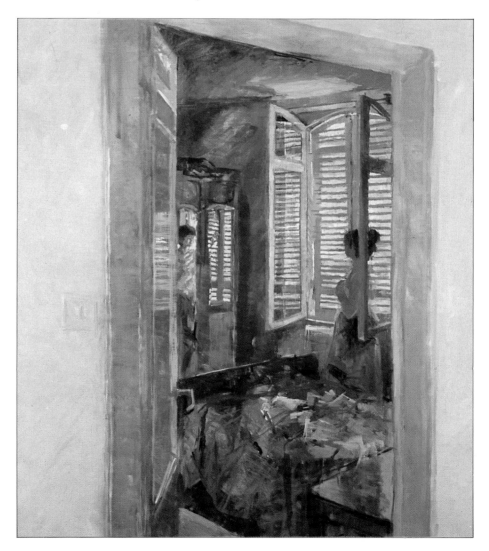

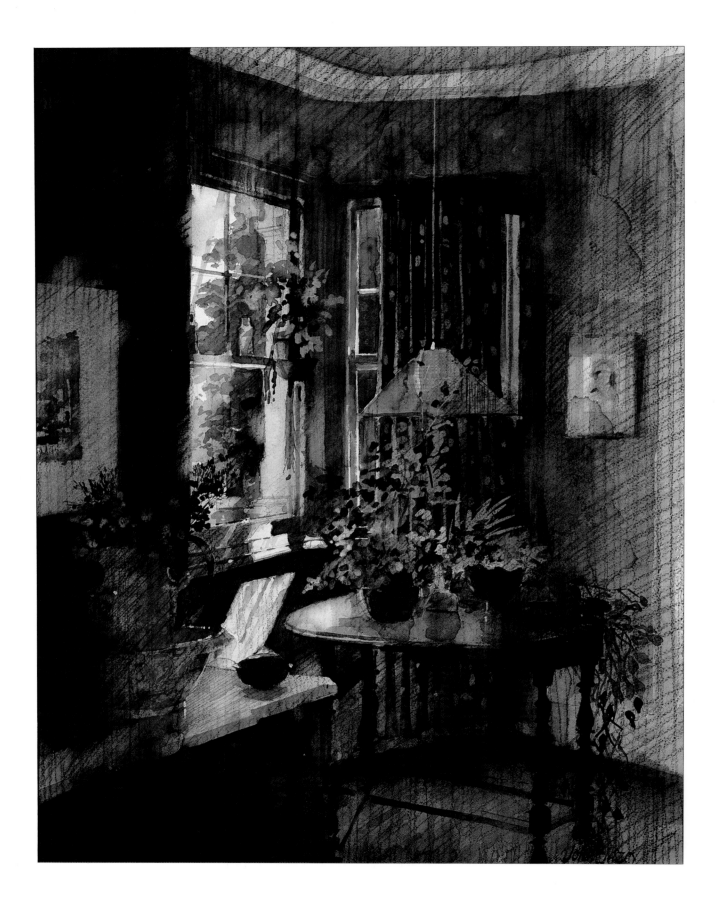

◀ **Suburban Interior 1** John Lidzey, *watercolour and conté crayon*

These two paintings, versions of the same subject, show the dramatic changes brought about by slight differences in light. Notice how the artist has varied the composition to suit the lighting conditions. Here he chose a viewpoint which allows the sharp diagonals of the washstand on the left to balance the bright, angled patch of sunlight below the window and the equally bright curved edge of the round table. The picture is an exercise in chiaroscuro, with an almost spotlit effect in the centre.

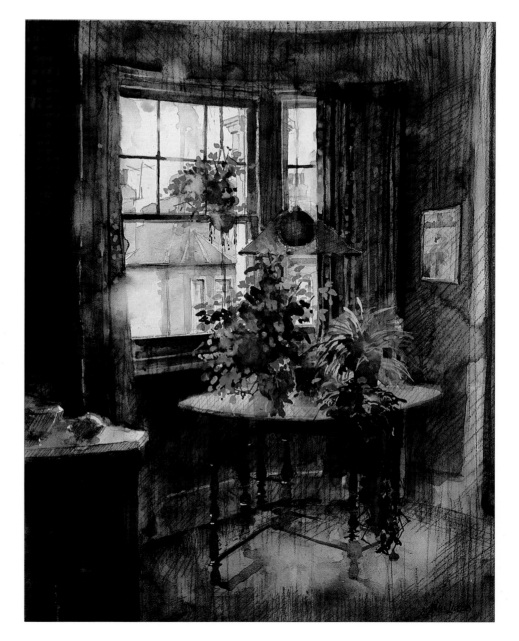

▲ **Suburban Interior 2** John Lidzey, *watercolour and conté crayon*

In this picture the light is more diffused, and the whole surface of the round table, with its array of plants, becomes the focal point. Its curves are echoed by the light patch of floor below, and neatly counterpointed by the near-triangle formed by the top of the washstand. The role of light in interiors is so central that it is possible to produce a great many paintings of the same thing without ever repeating yourself.

ART SCHOOL

· ·

RECORDING LIGHT

It is a valuable exercise to make a series of quick colour sketches at different times of day, as this will teach you how light affects both colour and form. Claude Monet, with whom light was almost an obsession, used to paint several on-the-spot landscapes in one day, sometimes completing each one in under half an hour. But for beginners it is not quite so easy, particularly when your subject is a complex one such as an interior, because you may find yourself wrestling with the drawing for so long that you will have neither the time nor the inclination to paint.

The following simple method allows you to get on with the important part. Make an outline sketch of your subject – at any time of day, as light does not matter at this stage. Decide which medium you are going to use for the sketches, and transfer your drawing to three or four pieces of paper suitable for that medium. To do this you can either employ

The drawing on the left was first reduced (by 50%) on a photocopier, as the colour sketches did not need to be as large. Several copies were then made by putting sheets of watercolour paper in the paper tray of the machine, and these formed the basis for the colour studies made at different times of day.

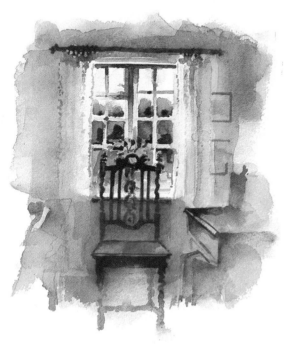

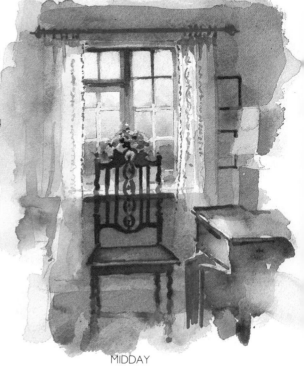

Morning palette

1 Yellow ochre, cadmium red
2 Cadmium yellow, ultramarine
3 Aureolin yellow, ultramarine
4 Payne's gray, cadmium red
5 Alizarin crimson, ultramarine
6 Indigo, aureolin yellow

MORNING

MIDDAY

Midday palette

1 Winsor (phthalocyanine) blue
2 Lemon yellow, yellow ochre
3 Alizarin crimson,
 ultramarine
4 Lemon yellow, Payne's gray
5 Cadmium red, alizarin
 crimson, yellow ochre
6 Raw umber, ultramarine,
 cadmium red

Night palette

1 Cadmium red, ultramarine
2 Ultramarine
3 Cadmium red, yellow ochre,
 ultramarine
4 Lemon yellow, ultramarine
5 Lemon yellow, ultramarine
6 Yellow ochre, alizarin
 crimson

the time-honoured "home-made carbon paper" method of tracing it, scribbling on the back of the tracing paper with a soft pencil and then drawing over the lines. Or you can use carbon paper of the kind sold in art shops for this purpose.

You can make as many copies as you want, and all you now need are the colours. Use any medium you are happy with, preferably one you have used before and whose particular ways you know. Watercolour, pastel and gouache are all excellent choices, as they enable you to put down impressions quickly – and speed is the essence here. Oils are slightly less suitable, but if this is your favourite medium it is probably best to stick to it. In this case, work fairly small and try to cover the surface quickly. Personally, I am very fond of working in oil on paper, as the paint becomes absorbed immediately and thus dries very fast, so it is possible to overpaint without muddying the colours.

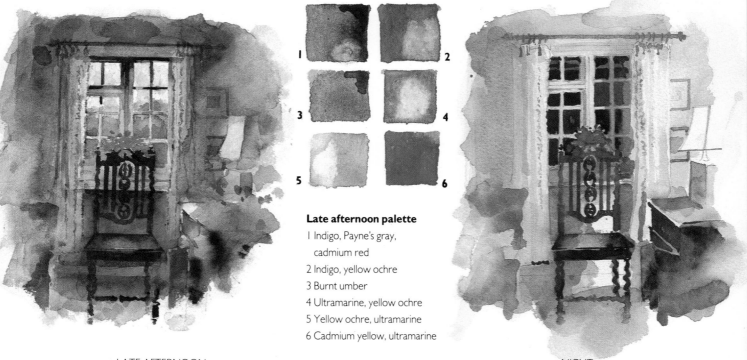

Late afternoon palette

1 Indigo, Payne's gray,
 cadmium red
2 Indigo, yellow ochre
3 Burnt umber
4 Ultramarine, yellow ochre
5 Yellow ochre, ultramarine
6 Cadmium yellow, ultramarine

LATE AFTERNOON

NIGHT

ARTIFICIAL LIGHT

···································

How can I best exploit artificial light?

There is a prejudice against artificial light among amateur painters, probably stemming from the fact that they have not made the distinction between the light you paint under and the light you actually paint. It is perfectly true that if your work surface is lit by standard electric light you will not be able to judge the colours as well as you would in daylight, but as subjects for painting, scenes illuminated by lamplight, firelight or candlelight have great possibilities, and it is a pity to ignore them.

Something most of us know but seldom realize fully is that the levels of natural light, even on a dull day, are very much higher than those of artificial light. An electric light can look very bright close to, but try taking a photograph of someone sitting a few yards away and you will find that your camera will not function without flash. One of the effects of this rapid falling away of illumination is that spaces become smaller and more enclosed, creating a cosier, more intimate effect than daylight. In the 17th century, both Rembrandt and the French painter Louis Le Nain chose to use lamps or candles as the primary light sources in their religious compositions, because of the way this type of light drew the figures together and threw them into prominence against a darker background.

Playing with light

This spotlight effect can be used to great advantage in an interior, whether it contains figures or not, and you can play around with movable lights to create endless compositional variations. Sunlight will provide lovely patterns of light and shade, but it is not controllable, whereas a lamp can be placed wherever you want it and will cast attractive circles of light and curves of shadow to break up large vertical or horizontal areas. The colours will change too, becoming warmer, with a higher proportion of yellow and red.

So if you are looking for a new angle on an interior, or want to convey a different atmosphere, it is well worth experimenting with various lighting effects. You could try a combination of firelight and lamplight, or two separate

You can play around with movable lights to create exciting compositional variations.

▲ **Building a reference store**
It is difficult to paint in ordinary electric light, but perfectly possible to make quick sketches of light and shadow effects from which you can construct a full-scale painting later. You could also use watercolour or pastel to make colour notes.

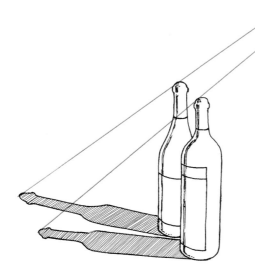

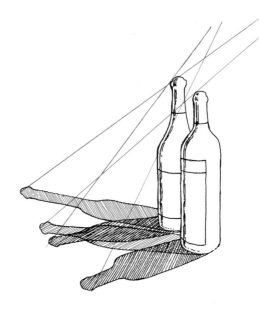

▲ Single-source shadows
Shadows cast by artificial light are less strong than those cast by sunlight, although clearly defined when close to the light source.

lamps that create intersecting circles, but avoid too many different light sources.

The least interesting type of artificial light is an overhead one which, because it throws the minimum of shadows, has a flattening, deadening effect. This is not to say that overhead lighting can never be effective: the American artist Edward Hopper painted groups of solitary strangers in cafés lit by a harsh strip lighting that increased the feeling of loneliness and alienation.

▲ Double-source shadows
If there are two light sources, such as an overhead light and a table lamp, the shadows will overlap, creating exciting visual effects.

► Twilight Interior Naomi Alexander, *oil*
A lovely warm glow is cast by the light, creating a relaxed and intimate atmosphere. In spite of the large expanse of table in the foreground, the artist has cleverly exploited the feeling of enclosed space by using a small range of colours, repeating the yellows, mauves and golden-browns from foreground to background. The table lamp which lights the figure emphasizes the focal point of the picture, but it is not the only light source in the room; the pool of shadow on the table indicates there is another somewhere to the left.

INSIDE LOOKING OUT

. .

How do I tackle the view through a window?

The way in which you approach this depends very much on the aim of your painting. Window views, or glimpses of the outside world seen through open doors, have always fascinated artists, as they provide an intriguing and challenging set of pictorial possibilities. But like all good subjects, they have their attendant problems.

The main difficulties are those of creating a sense of space and emphasizing the different qualities of inside and outside without losing the unity of the picture. Of course, not everyone sees things in terms of space – some artists will deliberately ignore it, treating interior walls, windows and the outside landscape as a more-or-less flat area of colour and pattern. If you want to do this, fine, but if your approach is more literal, the following advice may be helpful.

Framing a view

First decide how much of the picture area is to be devoted to the view out of the window or door. Suppose this view is an exciting cityscape and you want to make it the main subject of the painting, with the window itself acting as little more than a frame around the edges. In this case, you can treat the scene just as you would if you were painting it outdoors. But you will have to give extra emphasis to the window in terms of tone or colour – or both – because objects nearer to you always have brighter colour and more tonal contrast (a more obvious division between light and dark) than those in the middle and far distance. This is a neat way of giving a feeling of space and recession to the view itself, because the window will immediately come forward to the front of the picture – known as the picture plane.

Inside/outside

But you may be as interested in the interior of the room as you are in the view, and herein lies a treble danger. First, you may find that the painting begins to divide into two separate pieces – a landscape and an interior – which do not relate to one another. Secondly, the landscape may start to crowd into the room instead of occupying its proper place in

Glimpses of the outside world seen through an open door or window have always fascinated artists.

▶ **Kitchen Window with Geraniums** Carolyne Moran, *gouache*
The rich patterns of the garden plants outside are an integral part of this composition, so the artist has not attempted to create much degree of depth. However, the crisp treatment of the window bars and flowerpots isolates the foreground from the background and gives a firm structure to the picture.

space. And thirdly, if you have been over-zealous in space-creating, the landscape may recede so much that it no longer forms an important part of the picture.

The first and third of these potential problems can be overcome by creating a series of pictorial links between inside and out. For example, if there is bright sunshine outside, make the most of any patches of sunlight that come into the room. If your outside scene includes trees or plants, echo them inside by inventing a foliate wallpaper or curtain, or even a touch or two of green in a shadow. If the landscape has a preponderance of one colour, use some of the same colour or a related one in the foreground as well. Try to limit your palette so that you do not use one set of colours for the outside and another for the inside; nothing could be better calculated to destroy the unity of a picture.

The second hazard, that of an encroaching view, is easily avoided by keeping the tonal contrast stronger in the foreground, as described above. You might also include a brightly coloured object in front of the window, such as a patterned curtain or a vase of flowers on the sill, which will help to push the landscape back. Or you can exploit the contrast between cool and warm colours, one of the most interesting features of outside/inside subjects, using warm reds, yellows and browns, which tend to come towards the

picture plane, in the foreground, and cooler blues, greys and blue-greens for the landscape.

Holding back

Finally, you may find that the picture you want to paint is the interior itself, but the window is fortuitously present, and you must decide how to deal with it. You may choose to ignore the view altogether, and simply paint the window as a bright area representing sunshine, or an overall neutral which does not draw attention to the outside world. This can be successful, but it sometimes makes a painting look curiously blank and unfinished, like a mirror with nothing reflected in it. If you want to suggest the view without letting it take over the picture and compete with your centre of interest, treat it with the minimum of detail, as little tonal contrast as possible and no bright colours. For obvious reasons, this is known as "holding it back".

▶ **Interior, Maison des Palmes** Jane Corsellis, *oil*
The brightness of the garden is perfectly balanced by the rich, deep, glowing colours of the interior. The two parts of the picture are linked by the figure of the waiter entering with his tray and by the diagonal shaft of sunlight across the floor.

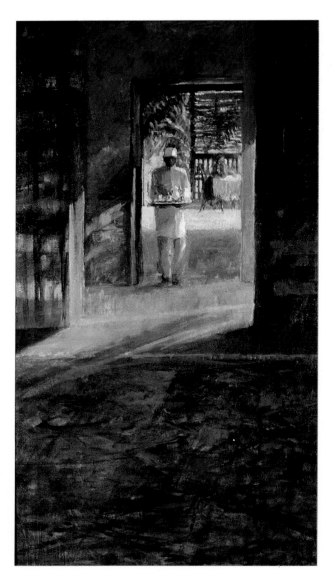

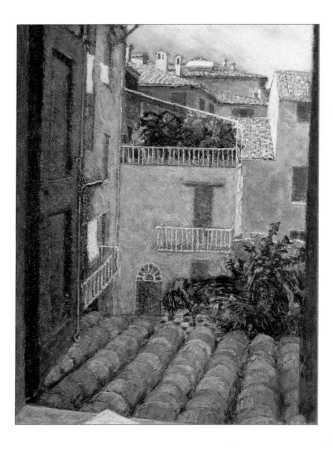

◀ **Window in Bologna**
Patrick Cullen, *pastel*
Here there was no need to make the outdoor parts of the scene recede, as they are the focal point of the picture. The open shutters act both as a frame for the exterior view and a means of taking the eye in to the centre of the composition.

▶ **Interior with Desk and Chair** John Lidzey, *watercolour*
The houses outside have been deliberately "held back", with the minimum of detail and tonal contrast, so that they do not compete with the interior.

▼ **Interior with Flowers**
Jane Corsellis, *oil*
The eye is automatically drawn to the delicate flower arrangement on the highly polished table, but even so the window view might have assumed too much importance simply because of its central position. The artist has prevented this from happening by muting the colours of the background trees and by using strong contrasts of tone for the shutters and wall. The creamy white of the left-hand shutter echoes the colour of the sky behind the trees but is more powerful by virtue of its shape and mass.

▼ **Through the door** John T Elliot, *oil pastel*
Artists sometimes like to play tricks, and this is what Elliot has done here. Although the title tells us that this is a view through a door, the "view" in fact looks like a picture stuck onto the wall. This is because all the warm, bright colours are concentrated in this small rectangle, and instead of receding into the distance they jump forward, almost hitting us in the eye. Nor does the optical illusion end there. If you look very carefully you can see that the bottom part of the picture, below the "view", is floor, but at first sight it seems that all of the grey-green area is wall. It is a clever exercise, and the perfect illustration of how tones and colours can be controlled by artists who know what they are doing.

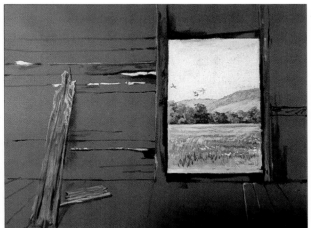

·········· Q & A ··········
INHABITED INTERIORS

Are interiors more interesting with people in them?

A *figure will inevitably become the focal point of a painting; you may have to prevent it stealing the show.*

Once again, it very much depends on the aim of your picture. If what interests you is the still-life aspect of interior painting, a person could be an intrusion, bringing in an element that is at odds with the subject. But all interiors, even those of historic buildings, are or have been settings for human life and activity, and the inclusion of one or more figures can be an excellent way of making a more positive and specific statement in a painting.

Playing it down

The most important thing to realize is that a figure will inevitably become the focal point of your picture, because the viewer cannot help but identify with a fellow human. This may be useful if you are finding it difficult to establish a focal point, but it means that the person may steal the show, which may not be what you want.

So, at least initially, try to think of human figures as pieces of furniture. See them in terms of colour, shape or as a vehicle for the play of light. Never make the mistake of painting the room broadly and freely and then labouring over the figure-painting aspect – this is a common error among amateurs, who often feel under an extra obligation to be true to a human subject. If you treat the person or people in one way and the inanimate objects in another, you will immediately set up a discord between them instead of a harmonious blending.

Think carefully about the colours. If you have chosen a colour and tonal key for the interior, make sure that your figures fit into it – persuade them to put on different clothes if necessary. In a pure white room, a person dressed in black could make a dramatic essay in contrasting tones, but someone wearing bright red in a scheme of creams or neutrals might stick out like a sore thumb. Equally, of course, the red could provide just the right accent of pure colour – it all depends on the proportion in which you use it. Whatever colour scheme you choose, always try to tie the figure to the surroundings by echoing colours from one to another, so that you establish a pictorial relationship.

▶ **Memories** Naomi Alexander, *oil*
The figure is undoubtedly the focal point in this picture, but blends in perfectly with the rest of the composition. The artist has restricted herself to a fairly small range of rich colours, repeating them from one area to another to form a series of links. By treating the figure broadly, with no more than a hint of definition in the features, she has avoided any strong feeling of identification with a particular person.

The power of suggestion

Another way of giving the human touch to an interior without actually including a figure is to provide visual clues in the form of a few of the occupant's possessions. A desk with books on it, or papers in disarray, can say an amazing amount about the room's user.

This brings us back to the narrative content of painting, which was mentioned earlier in the chapter. Knitting or embroidery on the arm of a chair, a sketchbook on a work table, a pair of walking boots near a door – all these can suggest the interests of the person whose room or house is depicted. In the same way, you can describe activities without painting them. A kitchen or dining room table with a half-empty bottle of wine and crockery disarranged will proclaim the end of a convivial evening – as well as giving you the opportunity to play with an interesting focal point for your painting. And a totally empty room denuded of furniture and possessions, will also suggest people – the viewer will speculate as to where they have gone, and why.

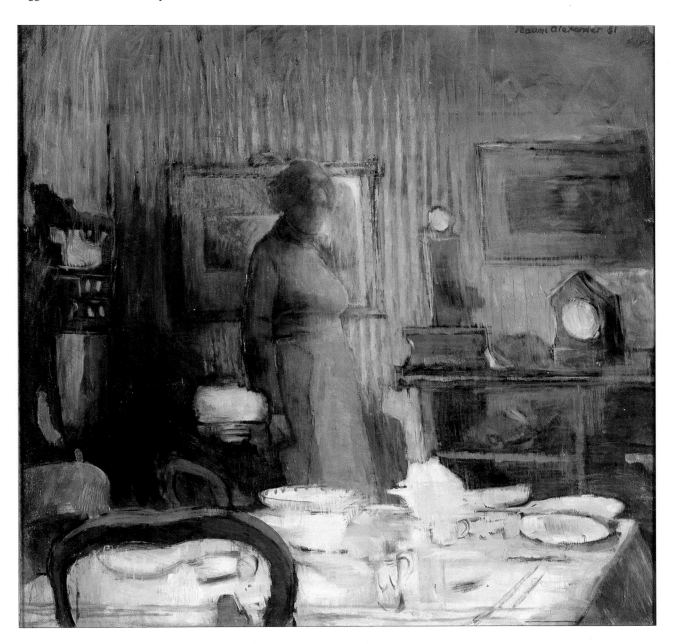

PATRICK CULLEN
PASTEL DEMONSTRATION

Cullen particularly enjoys painting interiors, as he finds that the combination of colours, textures and geometric shapes allows him to experiment with compositional ideas. Here the emphasis is very much on colour and pattern. He works in oil and watercolour as well as pastel, but has chosen the latter for this picture as it enables him to lay large areas of rich colour very quickly.

▲ **I** Pastel can be done on any paper that has a slight texture; if it is too smooth the pastel will simply fall off. For this picture a watercolour paper has been chosen, which was first stretched and then coloured with a watercolour wash. Pre-colouring the paper is common practice, as white can be very distracting, and makes it difficult to assess the first colours. The paper specifically sold for pastel work comes in a wide variety of colours from subtle greys and beiges to bright primaries.

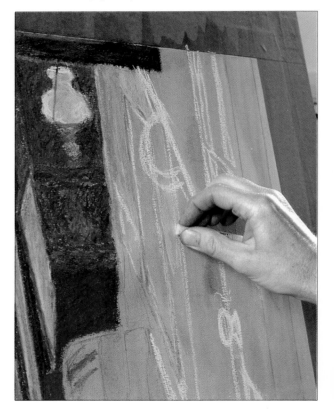

▲ **2** Having made an outline drawing in white pastel and established some areas of colour at the top of the picture, the artist blocks in the yellow wall on the right. This bright colour acts as a key against which the other colours can be balanced.

▼ **3** Here a slightly pointed stub of pastel is used to make the dark line of shadow on the green couch. Soft pastels become worn down very quickly, but sticks can easily be re-sharpened by rubbing on a piece of sandpaper.

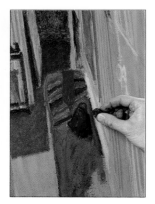

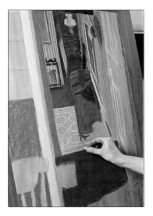

▲ **4** The outlines of the hexagonal pattern on the carpet are drawn in white before the individual colours are put in. It is always advisable to use pastel rather than pencil for preliminary drawing, as pastel does not thoroughly cover pencil lines.

▼ **5** Because pastels are so soft and crumbly, the colours tend to mix together when one is laid over another. To avoid this the artist has sprayed with fixative between stages. This also prevents accidental blurring of a completed area with the hand – pastels smudge very easily.

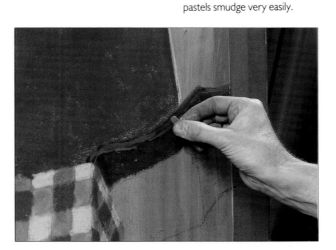

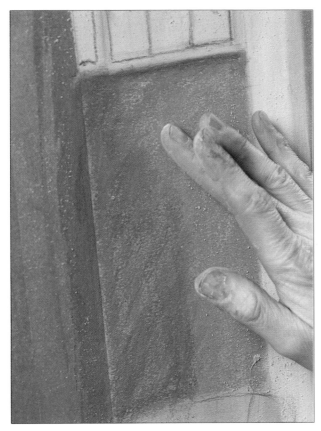

◄ **6** The fingers are used to blend the dark and light colours together. Blending is one of the most problematic aspects of pastel painting. Beginners tend to over-blend, which destroys the crispness and vibrancy of the colours and can create a woolly or muddy mess.

▲ **7** The texture of the paper plays an important part in the finished picture. Here you can see how the grain breaks up the line slightly to give a soft, diffused effect.

▶ **8** Pale pink highlights have been applied with the edge of the pastel stick and are now gently blended with a fingertip. For small areas like this, some artists prefer to use an implement called a torchon, a tight roll of paper.

▶ **9** Touches of brilliant blue act as a counterfoil for the warm oranges and deep reds in the foreground. To establish a relationship between the colours, the artist has chosen a warm blue rather than a cool one, which would look out of place.

◀ **10** A little of the ground colour has been allowed to show through the white pastel, which is only lightly blended. The oblong blind and vertical door jamb are essential to the composition, anchoring and stabilizing the other shapes.

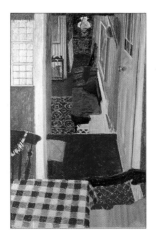

▲ **11** The picture is nearly finished, but two areas of foreground and middle ground remain unpainted. For oils and watercolours it is usual (though not essential) to cover all of the canvas or paper at an early stage, but because you cannot do a great deal of overworking with pastel it can be more satisfactory to work piece by piece in this way. No two artists use exactly the same technique, however, and once you become familiar with the medium you will discover your own methods.

▶ **Interior with Red and White Tablecloth** Patrick Cullen, *soft pastel on tinted watercolour paper*

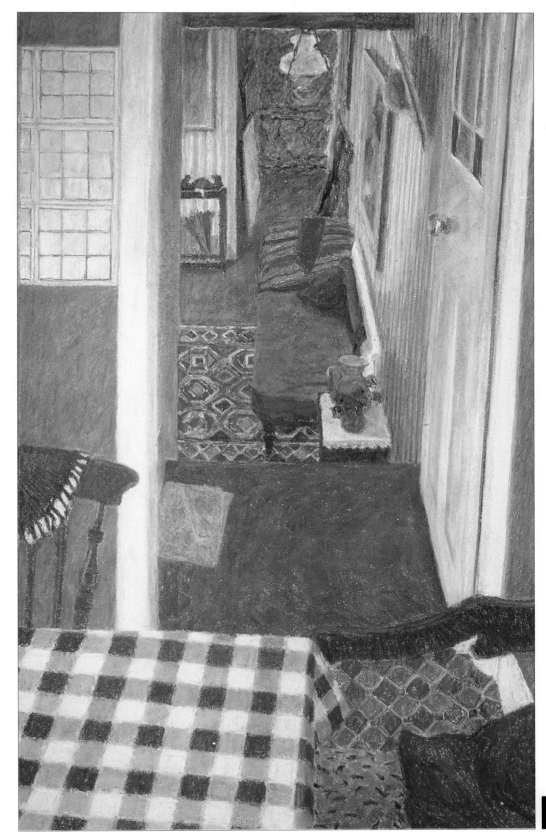

77

Composition with Palm Trees Ian Sidaway, *watercolour*

PART 3

····································

PICTORIAL VALUES

····································

PAINTING IS ABOUT MORE THAN CORRECT
PERSPECTIVE, AND ONCE YOU HAVE MASTERED THE
"ALPHABET", YOU CAN MOVE INTO THE HIGHER REALM
OF ARTISTIC EXPRESSION.

Q & A
VIEWPOINT

How do I select the viewpoint?

Once you have chosen the viewpoint you have taken the most important step in composing the picture.

With architectural subjects, particularly cityscapes, choosing a viewpoint can present something of a problem. The best viewpoint is the one that has the most potential for the kind of picture you have in mind, providing you with an interesting combination of vertical and diagonal lines, a good balance of lights and darks and some contrasts of colour. So far so good, but you also have to be far enough away from your subject to be able to work without moving your head – as we have already seen, as soon as you change position the perspective is altered. Thus the best viewpoint for a townscape is likely to be in the middle of a road.

However, there are ways of dealing with such problems. The first task is to make the choice, and here a viewfinder, or viewing frame, is a great asset. This simple device, nothing more than a rectangle cut in a piece of card, is illustrated on page 54. Shut one eye, hold the card in front of you, and you will immediately be able to see how your subject will look on canvas or paper. If the first view does not appeal to you, walk around for a bit trying out different angles of vision until you find one that has the makings of a good picture.

In general it is wise to avoid painting a building from directly in front. Choosing the viewpoint is the first step in composing the picture, discussed further overleaf, and the horizontal emphasis that results from a frontal view can make a picture look dull and static. A corner or oblique view not only provides an interplay of verticals and diagonals, which is more exciting visually, it also makes the building look convincingly solid.

High and low

Nor is eye-level always the best choice, though it has the virtue of familiarity. The height of tall buildings can be emphasized by a low angle of vision; a church or ruined building on the top of a hill will look more dramatic when seen from below. And a high viewpoint is equally exciting, particularly for townscapes, as it provides a dynamic upward-sloping perspective as well as a wealth of lovely and often unexpected details in roof tiles, chimneypots and so

▲ **Assessing the subject**
Sometimes the viewpoint is effectively chosen for you because there is only one possible place to paint from. For rural subjects like this, however, there are often several alternative vantage points, so spend some time walking around and looking before you make a definite choice. The drawing at the top, although fine for a sketch, would make a less exciting painting than the one above, which is a lively composition with good strong foreground interest.

on. Windows make marvellous vantage points, enabling you to draw in comfort and privacy and at the same time providing a ready-made frame to which you can relate the lines and angles of the roofs and walls.

The practicalities

But because the perfect viewpoint is seldom the most practical place in which to paint, townscapes often have to be done from sketches and photographs. Even if your subject is a building in a country setting, you will find that the changing light rules out prolonged painting sessions, so sketching and note-taking are essential. If you want to work from photographs, it is always advisable to make some colour notes to back them up. I use photographs a lot, and carry a small notebook in which to write a rapid description of the main colours – sky colour, shadows, dark side of building, light side and so on, so that I do not have to rely entirely on inaccurate colour prints. If you prefer to do quick monochrome sketches, you can make similar notes directly on them, and it is an excellent training for anyone who wants to learn to analyse colours.

▼ **Rooftops in Tuscany**
Patrick Cullen, *watercolour*
A window provided the vantage point for this study, and the artist has made the most of the verticals and diagonals provided by the walls and rooftops. A good composition should lead the viewer's eye into and around the picture, and he has made sure that this one does. Because of the way he has emphasized the field on the left, we are taken on a "tour" around the roofs, up the wall on the left, into the picture again by the field and thence towards the hilly distance.

▲ **Keble College, Oxford,**
John Newberry, *watercolour*
A low viewpoint was the perfect choice for this famous Gothic-revival building, stressing its angular height and outlining the pointed pinnacles against the sky. The artist has pushed his advantage further by placing the building uncompromisingly in the centre of the composition and leaving the sky as a pale monochrome wash of grey. The line of cars and dark figures in the street below give an indication of scale, while the single dark tree enhances the feeling of brooding strength.

▲ View of Delph, Winter
John McCombs, *oil*
Here the viewpoint chosen was
high enough to show the snow-
covered tops of the roofs,
making a pattern of light and
dark across the picture surface.

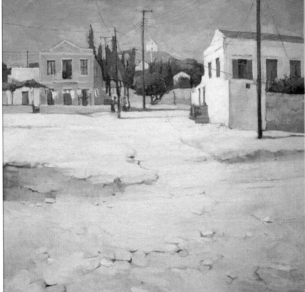

◀ Dodecanese Paul Millichip,
oil
Choosing the viewpoint is the
first step in composing the
picture, and an important
consideration is whether to go in
close or paint your subject from
a distance. Here the wide
expanse of foreground in no
way detracts from the buildings
in the middle distance and
beyond, indeed the stones and
the suggestion of a rough path
lead the eye in to them. The
strong contrasts of tone and the
repeated use of yellow and dark
blue ensure that they are the
centre of interest.

Q & A

COMPOSITION

Are there rules for composing a picture?

A great many artists, architects and critics of the past – from the Ancient Greeks onwards – have put forward theories about perfect proportion, harmony and balance in composition. But really the word balance is the only one that matters; a good composition is one in which there is a pleasing distribution of shapes, colours, tones and textures, and enough variety to hold the eye.

By the time you have selected a viewpoint you will already have made the main decisions about composition, so now you will only need to refine them. Work out what the centre of interest – the part of the picture to which the viewer's eye is led – is to be, and then consider how you can make more of it. In a cityscape, the centre of interest might be a tall building, rising above smaller ones. You could draw attention to it by emphasizing its colour or texture; you could sharpen the contrast between the shadowed and sunlit side; or you could use the diagonals provided by oblique perspective to lead the eye in to it.

Diagonal lines are among the most potent of all compositional devices, as the eye automatically follows them inwards. Horizontals have exactly the opposite effect, shutting the viewer out, so too much horizontal emphasis in foregrounds is best avoided. Fortunately, architecture provides a wealth of diagonals as well as verticals, which also have a naturally dynamic quality.

In general, it is not a good idea to divide a painting in half, either vertically or horizontally, as symmetry is static not dynamic. It is usually best to avoid a frontal view, with a building placed right in the middle of the picture area. If the building is a low structure, consider painting it from an angle so that you have a long and a short (foreshortened) wall.

You also need to be careful with cropping, which can happen by mistake. Drawings have a way of expanding as you work, so that you often find a tall building stretching out of the picture at the top. Cropping can be very effective, but it needs to be done thoroughly; allowing a roof to just touch the top of the paper will give a cramped feeling.

▲ **Rochford Barns 1** Martin Taylor, *watercolour*
A single scene can present a wide variety of potential compositions, and this artist often experiments by painting the same subject from different viewpoints (see opposite). Here he has used the line of the roof on one side and the sweep of the grass on the other to lead the eye in to the centre.

▲ **Rochford Barns 2** Martin Taylor, *watercolour*
For this version he has chosen a more central position for the right-hand barn, giving the composition a more horizontal emphasis than the other, which exploits diagonals. As a general rule, horizontals are more restful than verticals and diagonals, so unless they are planned with care they can make a picture look rather static.

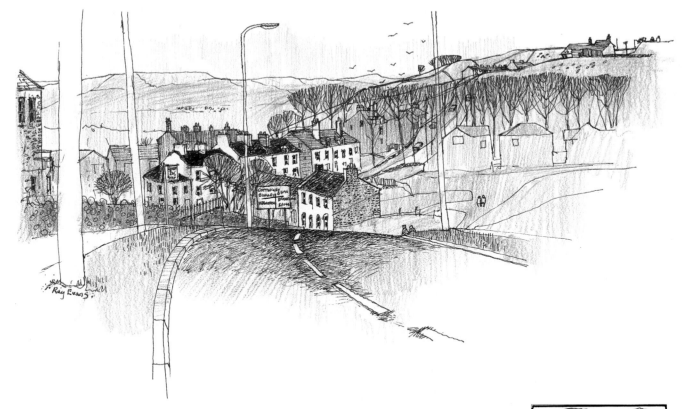

▲ Making a choice

One sketch like this (above) can become the basis for several paintings. Here the artist has chosen three, each one containing all the elements needed for a successful picture. You can do the same thing with photographs. Cut out two L-shaped pieces of card and move them around to isolate various parts of the picture.

▶ **St Paul's at Night** John
Lidzey, *watercolour*
In the context of composition,
the way the paint is put on can
be as important as the subject
itself. Here the loose wet in wet
treatment of the sky has an
almost tangible physical
presence, balancing and
complementing the clear
definition of the building. Lidzey
achieves his effects by applying
his paint very wet with a large
mop brush, allowing it to run
down the paper and controlling
it with blotting paper. He always
begins with a careful drawing, a
prerequisite for complex
architectural subjects.

◀ **Roussillon** Ian Sidaway,
watercolour
Good composition is as much
about what to leave out as what
to put in, and much of the
impact of this painting comes
from its clean, uncluttered look.
The artist has planned it in terms
of blocks of tone and colour,
each balancing the other, and
has paid careful attention to the
shapes made by the shadows.
Detail has been kept to a
minimum, restricted to the
central area of the picture, and
the paint has been applied firmly
and surely, with no hesitant
dabbling.

▶ **West Pier, Brighton**
Dennis Roxby Bott, *watercolour
and pencil*
A painting in pale, muted colours
with very little tonal contrast
could look weak and even dull,
but this one certainly does not.
A strong linear structure is
provided by the beams and
pillars of the pier in the
foreground and on the left. The
placing of the main pillar slightly
off-centre divides the picture
area vertically but not
symmetrically, while horizontal
divisions – also asymmetrical –
are formed by the foreground,
sea and sky area, and pier
gallery. The artist has suggested
texture in the foreground by
spattering wet paint onto dry.

ART SCHOOL

·······································

WORKING WITH PHOTOSTATS

The collages shown opposite form part of an album celebrating the art and architecture of Rome, and are by David Ferry, an artist who specializes in unconventional techniques and mixed-media approaches. Among the elements he used as starting points were a museum guidebook and photocopied colour prints. He frequently recopies and enlarges certain areas of photographs to produce rich textures.

The photocopier, once seen as a piece of equipment whose value is confined to office workers, is fast coming into its own as an extension of the artist's "palette". More and more painters and illustrators are using it, not only for prosaic activities such as enlarging drawings, but as the basis for works of art. Now that "high-street technology" has given most of us access to this machine, there is no reason why amateurs should not do the same.

Although there are certainly purists who shudder at the idea of harnessing technology to art, just as there are those who think it is immoral to use photographs as painting reference, such people are an ever-dwindling minority. Photographs and photostats (and a combination of both) can be used in many exciting and creative ways, notably to make the kind of collages shown on these pages.

Theoretically, the function of the photocopier is simply to copy, but it can also enlarge and reduce, and one of the side-effects of enlarging is the remarkable textures that can be produced. A perfectly ordinary and rather dull colour print can be transformed into something quite different by repeated enlarging, perhaps of just one area of the image. You can then paint or draw on top of the copy with crayons, coloured inks or markers, after which you could copy it again or introduce some other elements to form a collage. It is also possible to make texture photocopies of such things as pieces of fabric, grasses or dried leaves – indeed anything that can be placed on the glass slab of the machine can be photocopied, so the possibilities are really endless. Experimenting with photocopy art can be extraordinarily liberating, as it frees you temporarily from the hard discipline of drawing and encourages you to use your imagination.

▲ These are just three of the many photocopies that Ferry used for the collages. He tries out a variety of arrangements before gluing the pieces in place.

▲ Here the photocopied pieces have been assembled and glued, and the artist has drawn over certain areas with markers before recopying on ivory-tinted paper (top right). Notice that the red comes out darker than the blue in the copy.

◀ ▼ Photocopied photographs were again the starting point for this collage made for the same album. This was more extensively painted and drawn over to produce a variety of textures. Such "artwork" can either be left as it is, copied again in monochrome or colour "printed" on a laser colour copier, a relatively recent invention.

············ Q & A ············

LIGHTING

··

What is the best lighting for buildings?

Choose the light to suit the subject; the unemphatic light on a dull day could be ideal.

Outdoor light changes dramatically according to the time of day, and its intensity and direction determine the colours that we see. Most of us must have noticed how the hard light of the midday sun bleaches out colours, while in the evening they blaze out in vivid and often quite surprising glory. So if you intend to paint outdoors in sunlight, a good general rule is to avoid the middle of the day and paint in the morning or evening, when a low sun breathes life into the colours and throws slanting shadows which pick out details and highlight interesting textures. You will, of course, have to cope with a moving light source whenever you work on the spot, and this brings its attendant problems, so you may need to consider a series of work sessions, as suggested earlier.

But in matters of painting it is never possible to write a prescription that covers all circumstances. So much depends on the idea behind each individual picture. One person may see the ideal subject in the pattern made by sun and shade on the planes of walls and roofs; another may want to stress the linear qualities in a townscape, with little splashes of local colour in shop signs and hoardings, in which case light is not a critical issue. Even the shadowless midday light can be used effectively to give that feeling of shimmering heat which is an integral part of some places.

Nor is there any reason why you should always paint in sunlight. The unemphatic light on a dull day could be ideal for expressing the atmosphere of a grim town or the brooding bulk of an industrial building. Gentle, misty light has special attractions, producing whispering suggestions of shapes with soft, diffused outlines, muted colours and no clear detail. Both Monet and Turner exploited this kind of light in their paintings of London and Venice respectively.

The only truly useful rule about lighting is to give it as much thought as you would to viewpoint and composition – they are all part and parcel of the picture-making process.

▲ Giants in the Evening
Walter Garver, *oil*
A romantic glow is cast on these industrial buildings by the low evening sun. It is not difficult to imagine the very different atmosphere an overcast or rainy day would create.

▶ Church of St Hilda, Hartlepool Stephen Crowther, *oil*
Here also the artist has chosen an evening light, providing a lovely array of golden colours. The composition is given unity by the use of a paler yellow in the clouds.

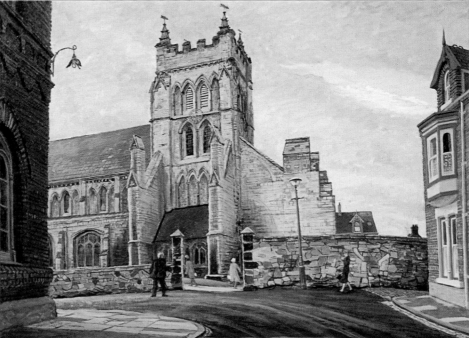

▶ **Sultry Afternoon in August** Trevor Chamberlain, *oil*
The fitful beams of sunlight through cloud act almost as a spotlight on the central group of buildings. Effects such as these can transform urban subjects, so it is worth making notes of them whenever possible.

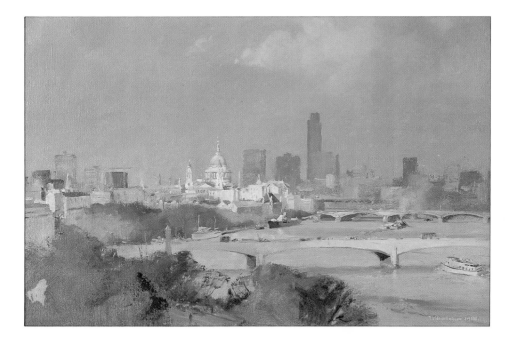

▲ **Behind Palmer's Greengrocers** Martin Taylor *watercolour*
The flat, unemphatic lighting is well suited to the sad, derelict houses. Sunshine would be out of place in this context.

▶ **Winter Scene** John T Elliot, *oil pastel*
Artificial light creates a pool of warmth and colour in an otherwise almost monochrome composition.

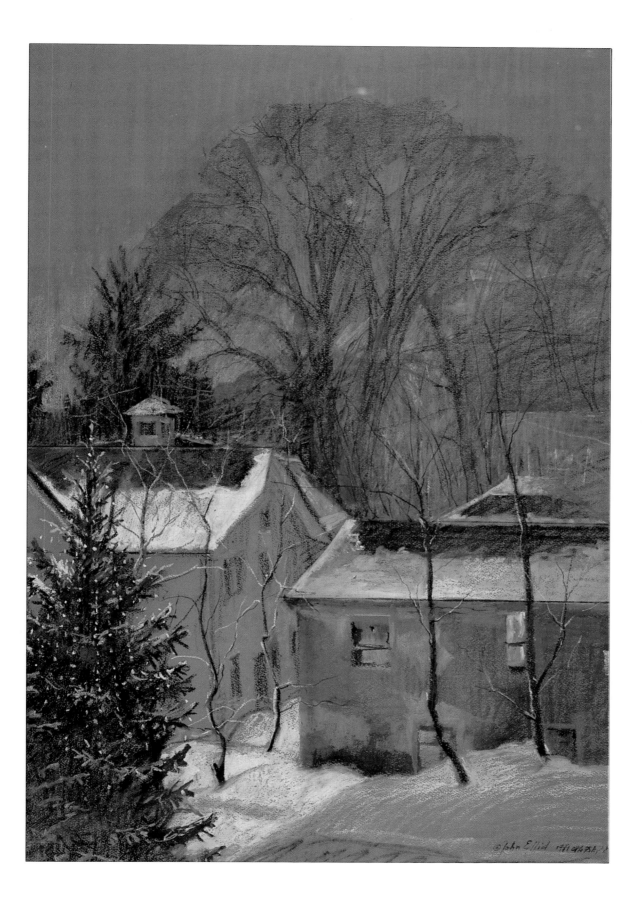

ART SCHOOL

PAINTING ON LOCATION

Painting outdoors directly from your subject can be an enjoyable and rewarding experience, but it can also be a frustrating one for those who are not accustomed to it. If you are working in bright sunshine, you may find that you are dazzled by an excess of light; your paints may dry too fast, and the chances are that you will have forgotten to pack some vital item of equipment. My aim on these pages is to provide some practical advice on what you will need, together with a brief run-down on the pros and cons of the different painting media.

The essentials

Unless you are painting in oils, in which case you may prefer to work standing up, you will need a small folding stool, low enough to enable you to reach your materials on the ground beside you. It is sometimes possible to find a convenient bench or chair at a café table, but you can't count on it, and sitting on the ground does not normally provide a good angle of viewing – in any case it is hardly practical in a town.

Painting under a hot sun can make you uncomfortable as well as dazzling you. It is often impossible to find a suitable patch of shade, so a broad-brimmed hat or cap is a valuable addition to your kit. So, too, is the viewing frame mentioned earlier. This will help you to decide on your viewpoint and composition before you start to work.

Oils

These are deservedly popular for outdoor work. You can cover large areas quickly and make alterations either by overpainting or by wiping off whole areas. They require a good deal of equipment, however. Unless you work on a very small scale, and can prop a board in the lid of a painting box, you will need (as well as your paints and brushes) an easel, canvases or painting boards – always take more than one so that you can start another painting when the light changes – white spirit for cleaning brushes and your hands, and a supply of rags or kitchen paper. A palette knife is also handy for cleaning up at the end of the session, and so is a plastic bag to hold paint-stained rags and brushes.

Watercolour

In many ways, this is the ideal outdoor sketching medium. All you need, in addition to your stool, is paper, paints, brushes, a bottle of water (unless there is a handy stream or fountain) and a jar. I like to work on a sheet of paper pinned to a light drawing board – this can be simply a piece of cheap plywood – as this provides a margin around my work, but the pads of watercolour paper that are sold for sketching are quite adequate. The board or pad can be held on your lap, though some watercolourists like to work standing up at an easel. This must be one that allows you to change the angle

of the board, because an upright surface will allow the paint to dribble down the paper.

Newcomers to watercolour would be well advised to practise at home in advance. It is a tricky medium to handle, and outdoor work requires a confident and decisive approach.

Gouache acrylic

Gouache paints are another version of watercolour, the only difference being that they are more opaque. You can dilute them well with water to lay transparent washes, but when used thickly, you can paint light over dark, which is not possible with watercolours. Many artists use gouache paints in combination with watercolour. The former's disadvantage for outdoor work is they dry very fast on the palette, and once hardened, the colour is difficult to release. Watercolours contain a gum that keeps them moist, but gouache paints lack this.

Acrylic

This is also a water-based paint, but the pigment is bound with a synthetic medium, and the colours, once dry, are immovable. Acrylics can be used thinly, like watercolours, or thickly, more like oils, and you can work on paper or on canvas. Their great advantages are that you can overpaint as much as you like, and your painting will be dry at the end of the day.

Acrylics will also dry on your palette and brushes, however, so it is essential to keep your brushes in water when not in use. The paint can be kept moist on the palette by spraying periodically with water, so put a plant mister spray on your list of equipment. Another option is to mix the colours with retarding medium as you lay them out, which

prolongs the drying time in proportion to how much is used. Personally, I do not find acrylic the ideal medium for outdoor work, though some prefer it.

Pastel

Theoretically, pastels are excellent for the job; all you need is the pastels themselves and paper, which may be either a sketching pad or separate sheets on a board. You can lay in colours rapidly with broad sweeps of the side of the stick, and if you use a coloured paper, as most pastellists do, you do not have to cover the whole surface – a speedy and economical way of working. Take plenty of papers of different colours so that you can choose one that tones in with the subject.

A disadvantage with pastels, however, is that colours cannot be mixed on a palette, which means that you must have a wide range of sticks in different colours and tones. Experienced pastellists know which ones they are likely to use most, but beginners can find that the right colour is never to hand when needed.

These paintings were all done by the same artist, working on location, but each is in a different medium – watercolour, pastel, oils and gouache, reading from left to right. As you can see, the convenience of a particular medium is only one of the considerations, as they all create very different effects.

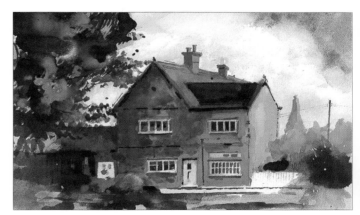

TEXTURE AND PATTERN

· ·

How can I get more interest into my paintings?

Recording texture and pattern

Often you will see considerable variations on the same building, or even on the same wall. This is particularly true of old structures, where rendering often wears away to reveal layers of other materials. Sketches like these (above and right) can be done very quickly, and provide valuable reference for paintings.

Many amateur paintings of buildings have a tendency to look drab, with all the walls a uniform grey-beige and the windows black holes. If you have this problem, it may be because you have not chosen the best lighting, but it is often due to a failure to exploit the surface qualities of buildings – the texture and pattern of walls, tiles, stones and bricks. These can sometimes be more exciting visually than the overall shape and proportion, but it is easy to become so preoccupied with getting the basic structure right that the really interesting things are overlooked.

Building materials vary enormously in themselves, and they are also affected by ageing and climate. Old, weathered bricks take on a lovely rich glow and the surface becomes rougher; both wood and stone mellow with age and attract grey-green or bright yellow growths of lichen or moss. Whitewash and rendering peels off or discolours in places to produce intriguing shapes and uneven textures. Old buildings provide the greatest variety of texture because of these accidental effects, but even new ones have texture of some kind, often the result of deliberate planning on the part of the architect or builder.

On the following pages you will find some tricks of the trade which will help you to achieve textured effects, whichever painting medium you are using, but pattern requires no special techniques. It is all around you if you look; it is just a matter of accentuating what is already there.

If you see that all the bricks in a wall are different colours, make the most of it, don't settle for a dull pink-brown over the whole area. Never be afraid of details; on the contrary, include anything that you think would add an extra sparkle to the picture – drainpipes snaking down a wall; brightly painted doors or windows; cast-iron curlicues on balconies; reflections in window glass; a patterned curtain seen through an open window; a line of washing breaking up the surface of a wall; billboards or even estate agents' signs. These are the things that give a feeling of life to architectural subjects, and even if the buildings are not strictly speaking alive, the people who pass through them are.

▶ **Skyscraper, Cleveland, Ohio** Ray Evans, *watercolour*
For this quick sketch the artist has chosen a close-up viewpoint in order to make the most of the chequered pattern of the dark-glass windows.

▼ **Clifford Street, Charleston** Ray Evans, *pen and ink*
This old town in South Carolina is a magnet for artists, for obvious reasons. The combination of the traditional wooden-plank buildings and the tall brick-built ones offers endless possibilities for exploiting texture and pattern.

▲ **London Wine Bar** Ray Evans, *pen and ink*
Shop and restaurant signs introduce a delightful element of pattern, and in this case there was the additional bonus of the ironwork and the scalloped decorations over the door. This was a study done for a watercolour.

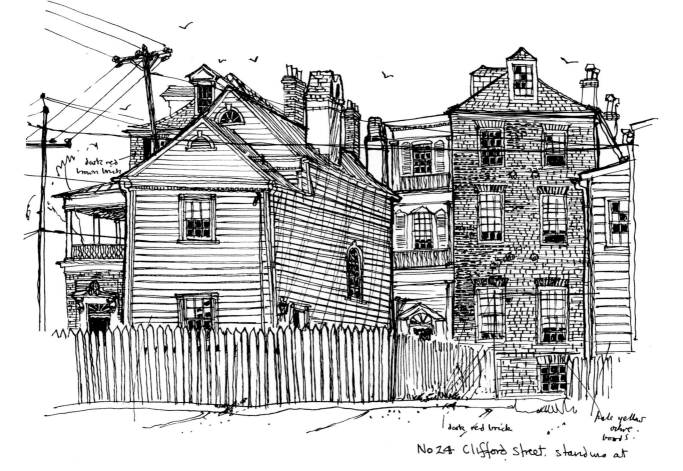

dark red brown brick

dark red brick

pale yellow ochre woods.

No 24 Clifford Street. standing at

◀ **The Green Door** Walter Garver, *oil*
There is no doubt about the artist's interests in this picture, and he has lovingly depicted every detail of the split wood and peeling paintwork. In terms of composition, however, the painting is almost abstract: a carefully balanced arrangement of lines and rectangles neatly pointed up by the freer forms of the weeds growing by the step.

▶ **Lower Manhattan** Sandra Walker, *watercolour*
A highly intricate pattern is created right across the picture by the windows, balconies and cast shadows. There is an amazing degree of detail, with each brick, windowsill and cornice rendered with great skill.

▶ The Rose and Crown

Stewart Ganley, *coloured pencil*
Ganley frequently works with coloured pencils, as they allow him to lay one colour over another, thereby building up carefully controlled mixtures with a lively textured finish. The white paper shows through in places, giving an attractive sparkling effect quite unlike anything that can be achieved with areas of flat colour.

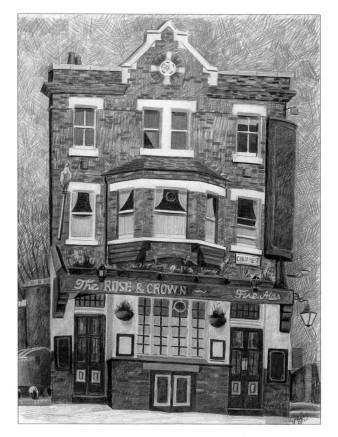

▼ Samarkand Moira Clinch, *watercolour*

Sometimes it can be difficult to decide whether to include every detail of an architectural subject or to attempt an overall impression. In this case, however, the choice was obvious. The marvellous colours and patterns of the Moorish tiles made an instant bid for attention, and the artist has done them full justice.

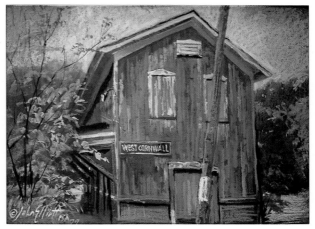

▲ Cornwall Station John T Elliott, *oil pastel*

As in Walter Garver's painting opposite, the artist's primary concern was for the texture and colour of the old wood with its peeling layers of paint. Oil pastel, his chosen medium, is excellent for rendering textures. It can be thinned with turpentine and used like paint, or applied dry like ordinary pastel, allowing a variety of surfaces to be built up.

ART SCHOOL

··

TEXTURING TECHNIQUES: 1

Thick impasto has been used over a thin underpainting which has been allowed to dry.

Oil paint mixed with glazing medium (this thins the paint without making it runny) has been rubbed into thick, dry paint.

Thick impasto applied with a small, triangular-bladed painting knife.

The contrast of textures presented by buildings is one of the most appealing aspects of this branch of painting; indeed, I have seen pictures in which textures form the main theme, with everything else – colour, shape, proportion and so on – playing a secondary role. This does not mean that you *must* make a feature of texture, but those who do want to show the qualities of weathered wood, stone and old bricks in their paintings, and are not sure how to achieve this, may find the suggestions and demonstrations on these pages helpful.

The methods that artists use to achieve their effects are many and diverse, and obviously they vary according to the medium used, so I have devoted these two pages to the opaque paints, oils and acrylics, while watercolour and mixed media are discussed overleaf.

Acrylic is a strange kind of paint because you can use it opaquely, like oil, or thin and transparent, like watercolour. The following techniques apply only to thick acrylic used on canvas or painting board.

Using impasto

Impasto is the technical word for paint applied thickly enough to stand out from the picture surface. This gives you a head start in rendering texture because you can make your brush describe it. If you are painting a stone wall, for example, you can suggest the separate stones by nothing more elaborate than the size and shape of the brushstrokes. The technique requires a sure hand and no dithering; each stroke, once laid on, should be left alone, as overworking will destroy the effect. It is best to work light over dark, beginning by laying an overall tone for the shadows and crevices between the stones. Do not use thick paint for this or it will mix with the top layer. Thin the paint for the toning layer well with turpentine or white spirit (use water for acrylics) and allow it to dry before applying the thick, juicy paint.

Light-coloured paint scumbled over a darker layer, which has been left to dry.

A layer of juicy paint laid over a dark underpainting has been scratched into with a pointed painting knife and a paintbrush handle.

This brick pattern has also been made by the sgraffito, or scratching method.

Brush impasto particularly evident in cloud formations.

Sgraffito method suggests planks on side of building.

Directional brushstrokes used over all the picture. Notice particularly roof, trees and side of house.

Knife impasto used in places, notably road surface and side of building.

Putting the paint on with a knife is a variation of the same technique. Painting knives, which have delicate, flexible blades and cranked handles, are sold in a variety of shapes and sizes. Do not use the ordinary straight-blade palette knife or you will quickly become discouraged – these are intended only for cleaning up and are too clumsy for manipulating paint.

Additives

Impasto methods, whether oil or acrylic, can use up a great deal of paint, but you can make it go much further by mixing your colours with an impasto medium. These, which are made for both oil and acrylic, thicken the paint without changing its colour and help it to retain the marks of the brush or knife. You can also try mixing your colours with sand or sawdust, which is a good way of imitating certain surface textures.

Scumbling

This is an old favourite in the artist's repertoire, and was used by innovative painters such as Titian long before it was given an official name. It is a method of scrubbing very dry paint over another layer so that the first one is only partially covered. The two (or more) colours may be contrasting or similar, depending on the effect you are seeking. An effective way of suggesting the rough or uneven texture of a stone or whitewashed building is to keep the successive layers close together in tone.

The only rule for this technique is that the first layer of paint must be thoroughly dry. Although traditionally used for oil painting, scumbling is even better suited to acrylics, as there is the minimum of waiting-around time with these fast-drying paints.

Removing paint

So far I have only dealt with putting the paint on the surface, but texture can also be created by taking it off. Scraping into paint is another tried and tested technique; Rembrandt used it extensively, making scribbled marks in wet paint with a brush handle to emphasize details of hair or the pattern of a lace collar. It is equally applicable to buildings, where it is ideal for describing wood grain or lines of bricks.

Wet paint can also be removed, or moved around on the surface, by combing, or dabbing with rags or paper. A particularly direct way of texture-making is to use a method known as a "blot-off". This is a simple printing technique in which a textured paper or fabric is placed on the surface and then removed, leaving an imprint behind. The possibilities are almost endless, so if you try out some of these ideas you will probably begin to evolve your own methods.

ART SCHOOL

· · · · · · · · · · · · · · · · · ·

TEXTURING TECHNIQUES: 2

A pale wash has been laid on very rough paper, and rather dry paint dragged over it.

The dry-brush technique is one of the best methods of suggesting the texture of bricks or stones. Here it has been worked over a lighter wash.

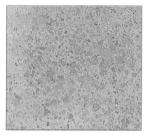

Paint has been spattered, blotted and then spattered again in three separate stages.

You may think that rendering texture in a transparent medium such as watercolour presents a major problem, but in fact there are quite a few methods that you can use. Before I describe any special techniques, however, it is worth mentioning that your first and most important tool is the paper itself. You cannot build watercolour up into rich surfaces in the same way as you can with the opaque paints, but the texture of the paper showing through the paint creates its own surface interest. You might make a start by trying out a rougher paper than you normally use, perhaps one of the hand-made types. The paint will settle unevenly, leaving little flecks of white showing through, particularly if you use it fairly dry.

Dry brush

As its name implies, this simply means working with very little paint on the brush so that the colour does not completely cover the paper. One of the most commonly used of all texturing techniques, it is often used for foliage, grass or hair in a portrait, but is equally well suited to buildings. The best brush to use is a square-ended one. Dip it in the paint; flick off the excess or dab it off on absorbent paper; fan out the bristles with your thumb and forefinger, and then drag the brush over the paper. You will produce a series of tiny, fine lines, which you can then work over in another direction and with another colour if you wish. When you are painting flat surfaces, such as walls, you will not want the effect to be too obvious, so avoid too great a contrast of colours and tones.

Spattering and sponging

Spraying or flicking paint over an area of flat colour is a quick and effective way of imitating texture. There are various methods. A fine spray can be produced by loading a toothbrush with fairly thick paint; holding it bristle side down above the paper, and running a finger over the bristles. To make larger drops, use a bristle (oil painter's) brush and give it a sharp tap with the handle of another one.

Interesting effects can be achieved by scattering crystals of rock salt into wet paint, leaving them to dry and then removing them.

A drawing was done with white wax crayon, and paint was then laid over the top.

Extra body can be given to watercolour by mixing it with gum arabic, so that it retains the marks of the brush.

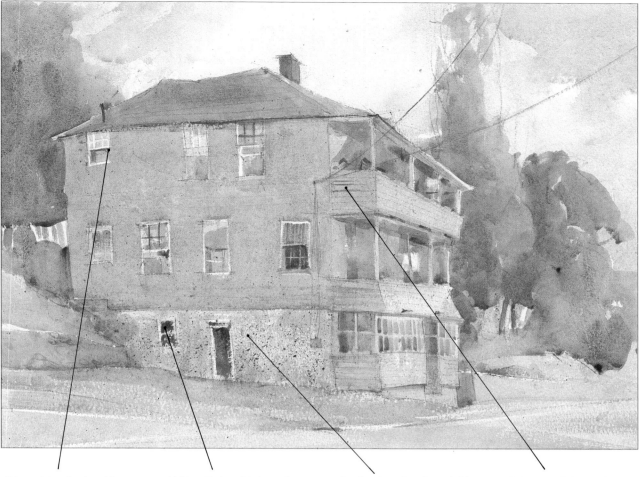

Wax resist method used for window and door frames and washing line.

Light spattering of darker paint on brick and plaster wall.

Dry-brush work on lower brick wall and doorway.

Original pencil drawing lines allowed to show through paint, suggesting wooden plank structure.

As in dry brush painting, you must take care to limit the contrast of colour and tone, or the effect will be obtrusive. If you are spattering over a light tone, the spattered paint should be only very slightly darker, so it will be too watery for the toothbrush method to work well. In such cases a mouth spray, of the kind sold for applying pastel fixative, is the best bet.

You will have to mask the parts of your painting that you do not want spattered. If the areas to remain clean are large, you can simply lay a piece (or several pieces) of newspaper over them. For smaller ones, such as door or windows, use masking tape cut to size. This can easily be peeled off without taking any paint with it.

You can also apply paint with a sponge, or dab a dry sponge into wet paint, both of which produce an uneven, mottled effect that can look both lively and realistic.

Wax resist

Most watercolourists experiment with this lovely technique at some stage. It is based on the mutual antipathy of oil (wax) and water, and involves drawing, scribbling or scrubbing with a candle or wax crayon before applying the paint. The water, with its colour, slides off the waxed areas, creating an attractive blotched or speckled effect, depending on the texture of the paper and the amount of wax you have used. You can cover broad areas – of a wall, for example – with the side of the crayon or candle, and use the point for finer details, so it is a wonderfully versatile method.

·········· Q & A ··········
LIGHT AND DARK

I am told tone is important. What do I need to know about this?

A *painting needs a good balance of dark, light and middle tones as well as a variety of shapes and colours.*

The word tone describes the lightness or darkness of a colour judged on a grey scale, with black at one end and white at the other. It has nothing to do with the degree of blueness or yellowness, which is called intensity, though of course some colours are naturally darker in tone than others. Yellow, for example, is always relatively pale, as it reflects more light than the pure reds and blues, which we perceive as dark.

At one time, tone used to be considered the most important aspect of a composition, and the grand historical and classical canvases that were fashionable before the middle of the 19th century were always painted in monochrome first, with the colour applied on top. The Impressionists overturned the applecart by taking virtually no notice of tone, but it is now generally accepted that a painting needs a good balance of light, dark and middle tones. It stands to reason, really, when you think of the literal meaning of the word monotonous – "all in one tone".

Analysing the subject

To achieve this balance you must put colour aside for the time being and think of your subject in terms of lights and darks. This is not as easy as it sounds; it involves a process of translation, because it is the colours that we notice. It helps to half-shut your eyes, which eliminates extraneous detail and lets you see things in simple blocks.

If you find that everything looks more or less the same tone you may need to rethink – perhaps you have not chosen the lighting wisely. If you have set out on an overcast day, it might be better to wait for a sunny one, which will give you a pattern of light and shade. Whether they intended to or not, the Impressionists usually achieved a tonal balance because they were interested in painting light, which naturally creates its corollary, shade.

When a subject has a wide range of colours, the tones will often look after themselves, but buildings are generally rather uniform in colour, and hence close in tone, so shadows may play an important part in your picture. You cannot always paint in sunlight, though, and you may not

▲ Sun and shade
In sketches like this, done with soft pencil, you can quickly establish a tonal framework for your painting. This drawing was done on the spot, but there is no reason why you should not make preliminary studies of this kind in the studio when you are working from another sketch or a photograph. If your original material was rather flat looking, you could think about giving extra emphasis to shadows, perhaps even inventing a different light source.

necessarily want to, so in the absence of clearly defined shadows you will need to consider how you might make more of the existing light and dark areas, such as white-painted windows or dark slate roofs. You might give the picture more contrast by exaggerating the darkness of a sky, a tree or some foreground element. You will find some suggestions for planning the tonal structure of a picture overleaf.

Yaxley in the snow perhaps!

▶ **Winter scenes**
Landscape in winter, with dark, bare trees and snow-covered ground, provides a built-in element of contrast.

▼ **Offices of Beale and Co., London** Patrick Cullen, *watercolour*
This picture is very tightly organized in terms of tone. The dark windows and lighter stonework make a pattern right across the paper, but the symmetry has cleverly been broken by the three irregularly spaced lit windows and the small foreground figure, which provides just a touch of shape contrast. An over-symmetrical arrangement of shapes, tones or colours tends to make a composition look static, so for architectural subjects it is often necessary to introduce elements like these to give variety.

▶ **Church, Mykonos** Moira Clinch, *watercolour*
With the strong sun and whitewashed buildings of Greece as the subject matter, it is almost impossible not to have tonal contrast, indeed sometimes it is necessary to play it down. Here the dark tones, such as the shadows, have been kept to a mid-grey to retain the feeling of light airiness.

▼ **Church, Sifnos** Doreen Osborne, *watercolour*
It is interesting to compare this picture with Clinch's (left), as the subject matter is similar but the treatment of tone very different. Here the artist has chosen to step up the contrast, painting the sky an almost black blue. Notice that she has also used very dark tones in the foreground to provide balance.

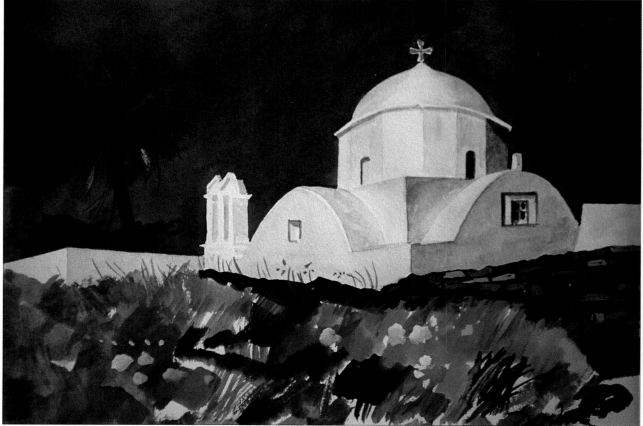

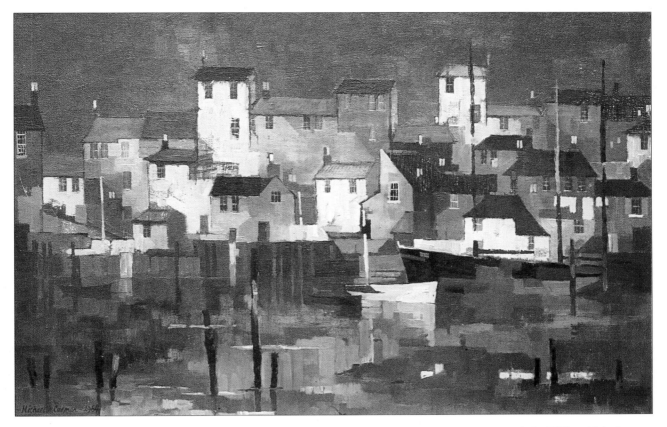

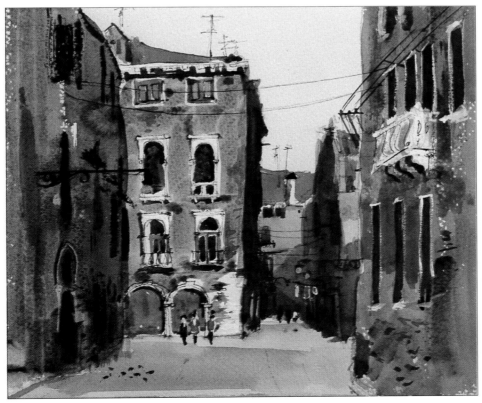

▲ **Red Village** Michael Cadman, *oil*
In this painting the light tones are distributed all over the picture surface, but in varying amounts, making the composition lively and full of movement.

◀ **Venetian Backstreet** John Tookey, *watercolour*
Here the dark shadows on the buildings are less central to the composition than the light-dark pattern made by the architectural details. You can often exaggerate features like this if a subject lacks contrast.

·········· Q & A ··········

HIGH CONTRAST

· ·

What colors should I use for shadows?

Subjects that have very obvious contrasts of tone, such as white buildings under a strong sun that casts deep shadows, may initially seem to be a gift to the artist, but they present certain difficulties. What usually happens is that you are so intent on the darks and lights that you forget about colour. Oil painters reach for the black paint, and then, when things don't look right, panic and pile more and more white on the highlights. Watercolourists, who have to leave the paper bare for the white areas, are often terrified of putting on any colour at all, and paint the shadows a timid grey for fear of sullying the whiteness.

Prevailing light

However dark the shadows look, you can be sure that they are not black. All colours are modified by the light that falls on them, and shadow is not an absence of light; it is only an absence of direct sunlight. A useful way of judging the true tone of a dark shadow is to line up a black object against it – a camera case or whatever you have to hand – and shut one eye. You will immediately see that it is nowhere near the black end of the grey scale and that it has a distinct colour of its own.

No color exists in isolation; shadows and highlights always have a direct relationship.

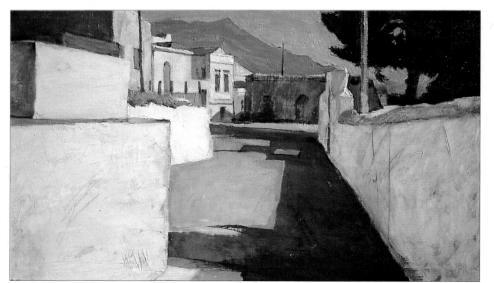

▼ **Greek Town** Paul Millichip, *oil*
The shadows are rich and dark, but they are certainly not black, and very little pure white has been used for the walls. The deep indigos and creamy yellows enhance one another, creating a lovely vibrant interplay of light and dark.

A common fault among beginners is to consider each part of a painting separately. But no colour can exist in isolation; because both shadows and highlights are seen under the same light, they always have a direct relationship, with the shadows picking up touches of colour reflected from the surrounding areas. If the light casts a warm, yellowish glow, the shadows are likely to contain deep blues, or even violets.

Guidelines

If you train yourself to look at your subject as a whole, relating the dark parts to the light ones, you will not go far wrong. But although there is no standard recipe for shadow colours, there are some useful facts to bear in mind when you are recreating a scene indoors. Outdoor shadows are always relatively cool in colour; in other words they do not contain large amounts of red, orange or yellow, and most have some blue, which is reflected from the sky. The Impressionists exaggerated this tendency, using little brush-strokes of pure blues, violets and sometimes greens, which gave their paintings a lovely vibrant quality.

They also claimed that they could identify in every shadow touches of the complementary colour of the object that cast it. Thus the shadow cast by a yellow house would tend towards violet, while that of a red house (if you happened to chance on one) would have touches of green. This is not always perceptible in the context of buildings, as they are seldom vividly coloured, but judicious invention is part of the artist's craft. Using complementary colours is an excellent way of giving an extra sparkle to a painting and bringing both shadows and highlights to life.

▼ **Summer Light, Pump Court** Trevor Chamberlain, *oil* There are no black shadows in this painting either. It is an interesting fact that deep blues, browns and greens often "read" as darker than actual blacks.

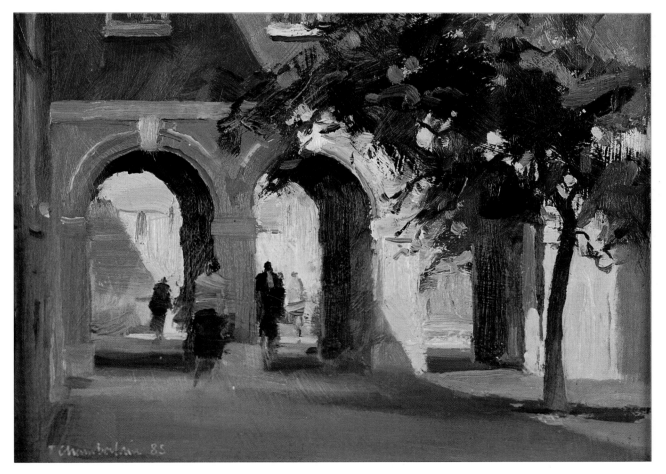

KEEPING THE COLORS CLEAN

My colors always become muddy. How can I prevent this?

To a certain extent, muddy colours are a built-in hazard of architectural subjects. Buildings do not always appear very colourful, at least on first sight. Bricks and tiles can certainly present a lovely array of colours, and in some parts of the world you do see attractive brightly painted or whitewashed houses, but it has to be admitted that there is a preponderance of greys, browns and neutrals, especially in urban buildings. Until you have learned to observe colours carefully and mix your paints with confidence you may find your paintings disappointing, but this is something that comes with practice. You may, however, like to try out one or two of the techniques shown overleaf.

Paint on a firm foundation

The main cause of drab, lifeless colour, however, is overworking the paint, and this is something you can avoid

▼ **Symi House** Paul Millichip, *oil*
Although the yellow of the house is nowhere near as bright as a pure, straight-from-the tube colour, it positively glows, and even in the dark areas, such as the doorway with its blue-grey figure, there are no muddy colours. One of the many things the artist needs to learn is how colours can be made to seem stronger by juxtaposition, and in this case the yellow is enhanced by the deep blue-grey of the sky and the rich red-browns of the woodwork and roof.

by taking more care in the early stages. Buildings, in the main, are complex subjects. Unless you admit this to yourself and ensure that you are working on a solid foundation, that is, a good drawing, you will have to keep on making corrections and overpainting because a window is in the wrong place or the line of a roof crooked. Clean, clear colours, whether the neutrals or the pure hues, can never be achieved by hesitant fumbling and applying layers of paint one over another.

Masking for straight lines

Things can go wrong at the painting stage too, however careful your drawing. One of them, perhaps the commonest cause of desperate overpainting, is that the straight lines start to waver and wobble, and as you pile on more paint they lose their crispness.

This is a particular problem for oil painters, as it can be quite hard to describe straight lines with thick paint and large brushes. There is an easy way round this difficulty, however, which is to use masking tape to keep selected edges clear of paint. You might mask the shadowed side of a building while you work on the rest, or mask the top of a roof while you paint the sky. This may sound mechanical, but in fact it takes the tension out of painting, and this allows you to work with greater freedom and concentrate on good clean colours.

Watercolour painters have an added advantage here, because they can use masking fluid as well as or instead of tape. This is a thick, rubbery substance which you can paint on with a brush, making shapes if you want, as well as straight lines. It is a marvellous way of keeping the paper clean for small highlight areas, avoiding the laborious process of painting round them, which can be yet another cause of tired, muddy colours. Wait for the masking fluid to dry before applying paint, and then peel it off when the paint is dry.

Taking drastic action

But however many clever methods you bring into play, you will probably still have to make corrections at some stage – even professionals do. For those using oils, the best course is to scrape down or wipe off the offending area – easily done with a palette knife and rag – and start again. There is another handy method called tonking, named after Sir Henry Tonks, a professor at the Slade School of Art in London. This involves laying newspaper or kitchen paper over the wet paint, rubbing it lightly and then removing it. The paper lifts off the surplus paint. So that you can resume work without the next layer of paint being sullied by the previous ones.

Removing watercolour is less easy, but you can often sponge down parts of a painting, and if you are working at home you can hold it under running water, which will remove most if not all the paint.

 San Gimignano Patrick Gibbs, *oil*
As in Millichip's picture, the paint has been applied freely but surely, with no overworking. Although the colours are all relatively muted, they are very definitely colours rather than indeterminate mud. Again the blue of the sky is used as a foil, this time for predominant pinkish-browns. A slightly darker version of the same blue appears again on some of the doorways and shutters, and as a line down the side of the left-hand block of houses.

ART SCHOOL

BROKEN COLOR

As was explained earlier in the chapter, you can make a colour, even a neutral one, look brighter or more distinct in hue by the way you juxtapose it with other colours. But artists have another trick up their sleeves, which is to use what is called broken colour. This involves mixing the colours on the paint surface as well as on the palette.

Broken colour

It is a curious fact that a flat area of colour, however bright, seldom has as much impact as one that is varied in some way. The Impressionists discovered that they could make the greens of grass and foliage look more truly green by using small brushstrokes of other colours – blues, violets and yellows – placed side by side. When seen from a distance these were perceived as green, while at the same time conveying the feeling of shimmering light.

This approach has more relevance to pure landscape than to buildings (though there is no reason why it should not be

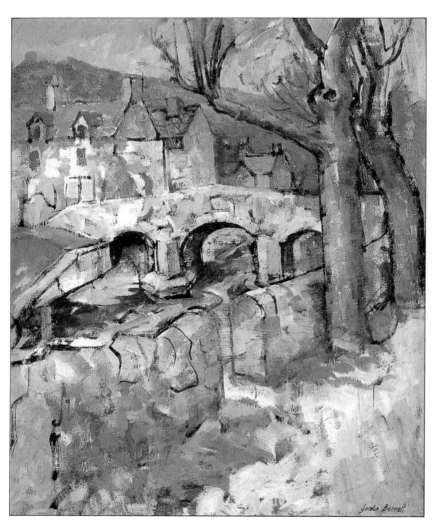

◀ ▲ Gordon Bennett works in oil, and here has used large flat-ended brushes to build up an intricate web of separate patches of colour. This gives the painting a lively sparkle as well as successfully suggesting texture. Because he has worked on an ochre-coloured ground, the small areas left uncovered between brushstrokes are unobtrusive.

▶ ▼ Arthur Maderson is a well-known "modern Impressionist" oil painter, and the technique he has used here is very close to Georges Seurat's Pointillism. Seurat pioneered the idea of optical mixing, in which small brushstrokes of pure colour were juxtaposed, to mix in the eye of the viewer when seen from the correct distance. The picture has been built up in layers, with increasingly thick, dry paint used in the later stages.

used), but there are other ways to break up colour, particularly if you are using opaque paints. In watercolour it is rather less easy, as this is by nature a fluid medium that does not retain the marks of separate brushstrokes. You can, however, use the dry brush technique described on page 102 or exploit the grain of the paper. If you drag a wash over either white paper or a previous wash that has been allowed to dry, the paint will only partially cover the raised tooth of the paper.

For oil and acrylic painters, a good method is to use a series of separate, square or rectangular brushstrokes, placed side by side, which produces an attractive mosaic-like effect. This is particularly well suited to buildings, as it suggests texture as well as bringing an extra colour element to areas of grey or brown.

This is an exciting technique, but it does need planning, since the illusion of a flat surface is quickly destroyed if the separate colours are too dissimilar in tone. The best method is to mix up several variations of a colour on the palette before applying them to the picture surface. You will also find it easier if you work on a toned ground, that is, a canvas on which you have first laid a flat, overall colour. Small patches of white appearing between brushstrokes are very distracting.

CREATING AN ATMOSPHERE

My paintings don't seem very expressive. What am I doing wrong?

When you are still learning and gaining experience as an artist, it seems a major achievement just to make your pictures look realistic, with the perspective and proportions correct, the straight lines straight and the colours more or less truthful to the subject. But there comes a time when you feel that this is not enough – you don't seem to be expressing your own feelings about your subject or conveying its atmosphere.

This is almost certainly because you have not given enough thought to colour and tone – in short, you have not learned how to orchestrate your pictures. Just as there are rules of perspective, there are also rules to help you express your emotions in paint; feelings will not emerge of their own accord. Perspective is the alphabet of painting, but colour and tone are the language itself. It is the way the artist manipulates this language that conveys his or her feelings and creates a particular mood in a painting.

▼ **Tuscan Farmhouse**
Richard Beer, *oil*
A very limited palette of ochres and greens produces a sense of gentle calm.

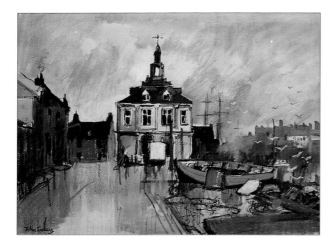

▲ **Customs House, King's Lynn** John Tookey, *mixed media*
All the colours are orchestrated to convey the feeling of wet, blustery chill.

Colour and emotion

In chapter 2, I mentioned the way some colours recede while others come forward towards the front of the picture. But this is only one of the properties of colours; they also have the capacity to evoke different feelings. Those that catch our eye and give us most uplift are the yellow and red range, while the blues, greens and blue-greys have a tranquillizing effect – often made use of to reduce anxiety in hospitals and waiting rooms.

The reds, oranges and yellows, and all the mixtures containing a high proportion of these, are the warm colours, which tend to give us just this feeling when we see them in a painting. The blue-based colours and cool neutrals, because they are more prone to distance themselves from the viewer, are quieter and less assertive. These are the ones to use if you want a calm and gentle atmosphere in a painting, while the yellows, reds and pinks suggest joy and excitement.

Colour and tone keys

This does not mean that you must plan an entire composition in shades of blue or of orange, but that you should decide on a colour key, or dominant colour, just as you would if you were planning a colour scheme for your home. Most successful paintings have an overall colour theme, often balanced or stressed by touches of a complementary colour – the colours opposite one another on the colour wheel, such as red and green.

So much for colour. The other vital factor is tone – the lightness or darkness of the colours you use. A low-key painting, one in which the tones are predominantly dark, gives a sober or even sombre impression, which can suit some architectural subjects, such as urban scenes and interiors, very well. And if the overall darkness is counter-pointed with some well-placed bright areas, such as golden glow of a street light or table lamp, or even some brightly painted shutters, you will have instant drama.

If you are seeking a relaxed, happy effect, on the other hand, keep the dark tones to a minimum and go for the light ones, with a touch or two from the middle range. High-key paintings are perfect for capturing the effects of light, so if your subject is a Mediterranean village or a sunny interior, use colours that are naturally light in tone, such as yellows, whites and pastels, and avoid the heavy hues such as dark green, crimson, deep blue and purple.

◄ **Charleston, South Carolina** Neil Watson, *watercolour*
The candy-floss pinks and delicate mauve-greys in this very high-key picture give an immediate impression of a sunlit, carefree lifestyle. There are no really dark tones, and the freely drawn ink lines heighten the jaunty effect.

FOCUSING IN

. .

I am most attracted by details of buildings. Can I make a picture out of a door or window?

Painting details gives you a chance to exploit texture and pattern.

It is surprising how many inexperienced painters shy away from homing in on specific details. One is often fired with enthusiasm by a lovely old wooden door with iron bolts and hinges, or a balcony with a shuttered window behind it, but the idea of making a composition of that and nothing else seems to be somehow dodging the issue.

It is no such thing, of course. It is a matter of exercising your individual right to choose what interests you most, and this is the first step towards becoming an artist. Architectural details make marvellous painting subjects, and there is no reason why you should feel you have to paint the whole building if you don't want to. After all, if you were embarking on a portrait you wouldn't think twice about cropping in on the face.

However, you will need to think carefully about viewpoint and composition, as a subject with only one main element can very easily become dull and static. Make some small sketches first in order to work out the best way of placing

▲ Architectural details
Often a detail like this lovely arched window has more pictorial potential than the building in its entirety.

▼ Seeing compositions
Sketching is a way of training the eye as well as improving your drawing. You will soon begin to see promising compositions like this all around you.

▲ **Entrée de l'hôtel** Richard Beer, *oil*
The stone- and brickwork creates a lively pattern, and the arches break up the horizontals and verticals to add variety to the composition.

▲ **Window, Holiday Cottage** Carolyne Moran, *gouache*
This delightful picture breaks the rules to some extent, as it is an almost symmetrical composition. Rules, however, are made to be broken, and the painting works perfectly. The symmetry is interrupted by the foliage just overlapping the windowsill, and interest is provided by the clever texturing of the brick and stonework.

your chosen piece of building on the paper in such a way that you do not have a too-symmetrical arrangement. A door or window is likely to be more interesting if you view it from a slight angle, which will allow you to suggest the depth of the recess as well as avoiding a preponderance of horizontals.

Lighting is a vital consideration too. Slanting sunlight will throw diagonal shadows which will not only balance the horizontals but will also highlight forms and textures. You might make a feature of texture itself, contrasting the grainy wood of a door with a whitewashed wall or the smoothness of glass in a window. In many ways such close-ups are the most challenging of all architectural subjects; to bring them off you will need to use all your artistic ingenuity, but it is enormously satisfying.

◄ Cleohill Cottage Porch
Carolyne Moran, *gouache*
The twisting branches and foliage and the flickering shadows create life and movement, while the open door adds an extra dimension, suggesting an invitation to enter.

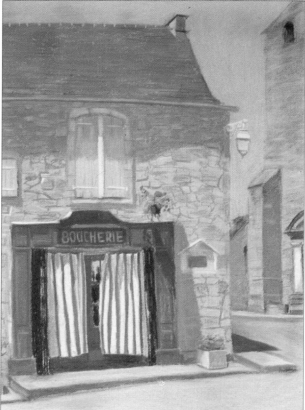

◄ La Boucherie, Domme
Suzie Balasz, *pastel*
This delightful picture makes clever use of shadow and texture, with a touch of movement conveyed by the striped curtains stirring slightly in the breeze.

▲ **Farmhouse Door** Martin
Taylor, *watercolour*
Texture is also used to good
effect here, but the real eye-
catcher is the bright blue door,
its colour enhanced by the
surrounding pinkish-browns.

▶ **Vesuvio Bakery** Ian
Sidaway, *watercolour*
Another skilful use of colour,
with the touch of deep red on
the right playing up the cool
blue-green. The basic symmetry
of the composition is broken by
the foreground bollard and the
curving shapes of the loaves.

........... Q & A

HUMAN INTEREST

My paintings lack atmosphere. Should I include people?

This question relates to the old problem of deciding what your painting is really about. Composing a picture, as we have seen, involves a process of selecting certain features for emphasis and rejecting others, and if you are dissatisfied with a painting because it lacks atmosphere, it is probable that you have excluded the wrong things.

If you are painting a ruined building in a grand, romantic setting, you may want to express the quality of peace and silence. In this case you might put in one small figure to give a sense of scale, but you certainly would not want to feature a gang of tourists with cameras round their necks.

In the same way, it is obvious that you will not be able to convey the living atmosphere of a bustling city or market town without its living beings, for the people are as much a

▲ **Foreground interest**
If you make a habit of sketching you will build up a store of references which you can draw on when a figure is needed in a painting. A bold shape such as this can often provide the perfect touch of foreground interest.

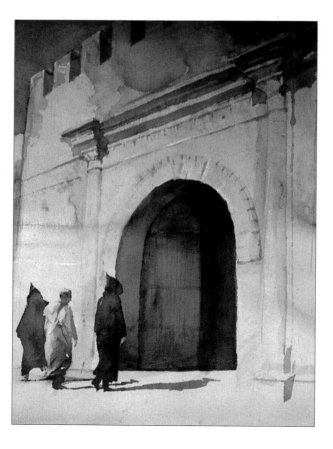

◄ **Town Gate** Paul Millichip, *watercolour*
The cloaked figures serve several purposes in this composition. They point up the size of the imposing gateway; they enhance the exotic atmosphere, and they and their shadows provide smaller dark shapes to balance that of the arch.

part of it as the buildings themselves. And if you are painting a modern city, why not include cars and buses? They have just as valid a claim for attention.

Inexperienced painters often avoid figures because they are not confident of their ability to draw them. The buildings are hard enough – why give yourself more problems? But if you treat figures very broadly, not as individual studies but as part of the landscape, you will not find it too difficult. You can often suggest a crowd or a group of figures by nothing more than small touches of colour or line and one or two dark blobs to stand for hair, clothing or a hat. This will also keep them "in their place", and prevent them from becoming the main centre of interest.

If you possibly can, avoid using photographic references for people, as photographs freeze movement as well as giving more detail than you need. If you are painting on the spot you will have to work broadly, as both the people and the light will change before you have time to think about detail. But photographs exert a peculiar tyranny; you feel obliged to put everything in. This will make the picture look static, whereas what you want to achieve is a feeling of movement.

Train yourself to make small sketches whenever you can. In this way you will learn to judge what is really important about a figure or group – the overall shape; the way someone stands or sits; a particular gesture, and so on. There is more about this important part of the artist's craft overleaf.

▼ Sketch wherever you are
People seldom notice if you sketch them in a café or pub. Always try to relate the figures to chairs, tables and backgrounds, as here, or you will find it difficult to fit them into a picture later.

▲ Sketching in colour
If you carry a small box of watercolours you can make a note of predominant colours, which are difficult to recreate from memory. This sketch took under an hour to complete, but is full of visual information.

◄ Sweeping up, Spitalfields Market Trevor Chamberlain, *oil*
The sombre buildings are really a backdrop for the activity of the figures. Notice the way the boldly curving brushstrokes in front of the figures and on the walls behind echo their postures, thus carrying the feeling of movement right through the picture.

121

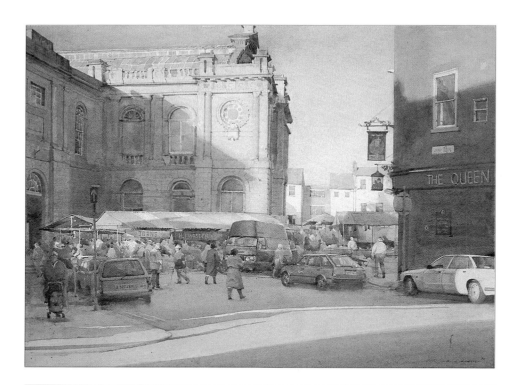

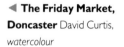 **The Friday Market, Doncaster** David Curtis, *watercolour*
Like many artists, Curtis draws on his reference library of sketchbooks for the people in his paintings, all wonderfully well observed.

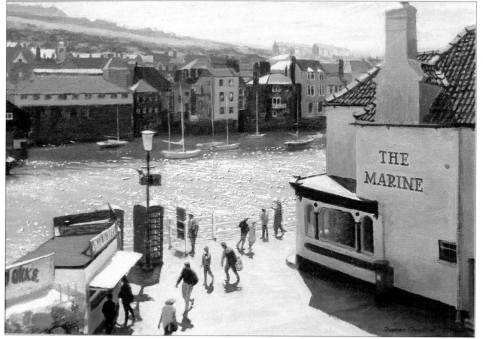

▲ **Sparkling Morning, Whitby** Stephen Crowther, *oil*
The scattered figures lead the eye in to the centre of the picture as well as giving a feeling of life and activity.

▶ **Interior, Kuala Lumpur**
Jane Corsellis, *oil*
Here the figures, in addition to creating marvellous simple shapes, have an important explanatory role, telling us what kind of interior is being depicted.

ART SCHOOL

LEARNING TO SKETCH

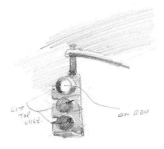

All the sketches on these pages were made by the same artist, for the painting shown opposite. For an ambitious cityscape like this you need to collect as much visual information as possible.

Every art teacher and every book on painting (including this one) stresses the importance of keeping a sketchbook, but it is something that many beginners find difficult. This is partly due to the embarrassment factor – no one likes the idea of people looking over their shoulder and being critical of their inept efforts. Sketching also has a tendency to show up weaknesses in drawing – it is one thing to take hours making a careful, measured drawing of a building, but quite another to record quick impressions in a meaningful way.

Sketching for practice

Once you have got into the habit, though, it becomes easier and more enjoyable. Even if your sketches do not initially seem very impressive, you will be learning to observe, and observation is the basis of good painting. So start out by

A rapid watercolour wash over a pencil drawing allowed the artist to record the direction of the light as well as the main shapes of the figures.

finding a quiet spot, such as an outdoor café, and single out some minor feature, such as a bollard, lamp-post, pillarbox or perhaps one window of a house. Do not be over-ambitious and try to produce a whole composition, as this is not what sketching is about. And do not worry about technique – the important thing is what you are drawing.

One of the difficulties of sketching is that you often have to work smaller than you are accustomed to. Drawing objects or people on a reduced scale also comes with practice, but if you find it a problem do not buy a tiny sketchbook just because it fits well into a bag. If necessary, buy a larger bag.

Here a rough indication of colour has been backed up by written notes. Experienced artists tend to analyse the colours they see in terms of the tube colours or mixtures that could reproduce them, and you can teach yourself a lot by trying to do the same.

Having assembled all the pictorial "fragments" he needed in sketch form, the artist began to plan the composition, making notes of changes to be made in the finished picture. Notice that the right-hand figures and the yellow cab, both of which play an important role in the picture below, are not included in this sketch.

You can use any drawing tool that you feel comfortable with, but it is best to take a selection of different pencils and drawing pens, and perhaps a broad-tipped marker or graphite stick. The latter is useful for blocking in areas of shadow quickly, and pens give a clearer, crisper line than pencils. Another danger with pencils is that they allow you to erase, and this leads to just the kind of laboured approach that you want to avoid. Leave the eraser at home, and if one sketch does not work, scrap it and start another.

Sketching for a purpose

Many paintings are composed entirely from sketches, sometimes with the help of a photograph or two and sometimes not. When you are making studies for a painting as opposed to simply drawing for its own sake, you need to give yourself as much information as possible. For example, if you are building up a series of quick figure studies for possible inclusion in a townscape, pay attention to the direction of the light and make notes about colours. Do not draw the figures in isolation, floating in the middle of the paper; indicate at least part of the buildings behind them as well. A few lines will usually suffice, but if you don't do this you will have no idea of the relative scale when you come to fit them into a composition. Always try to bear the painting you have in mind, and think of the sketches as one of the steps in planning it.

Midday Heat, New York
David Curtis, *watercolour*

RECESSION

· ·

How do I convey a sense of space?

Things do not only look smaller as they recede; they also become less distinct, so save the crisp details for the foreground.

In a townscape, where there are many buildings, the linear perspective will create its own sense of space – if you have got it right. Several sets of horizontal lines will become diagonal ones as they recede towards the horizon, and the buildings themselves will become smaller. However, it is all too easy to contradict the main perspective lines unless you are careful, and beginners tend to make two mistakes.

The first is failing to show enough variation in size between the bricks, stones and slates in the foreground and those in the background, and the second is to paint the details of far-off buildings too crisply. Things do not simply become smaller as they recede; they also become less distinct. If you half-shut your eyes you will barely be able to distinguish separate bricks on a house a hundred yards away from you.

The illusion of space can also be destroyed by inconsistent brushwork (watercolourists can ignore this, as it mainly applies to oil and acrylic painters). Because of the difficulties of painting details accurately with thick paint and large brushes, beginners tend to treat foreground buildings much too tightly, niggling away at them with a tiny brush. If the background is then painted more broadly (because you think

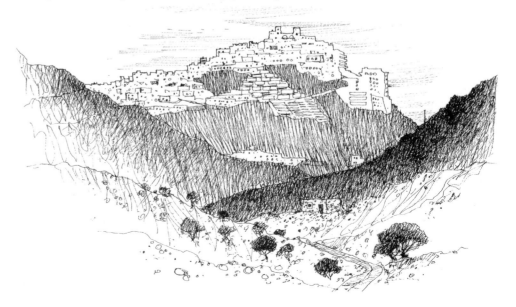

▲ **Mojacar, Andalusia** Ray Evans *pen and ink*
You do not have to use colour to suggest recession. In this sketch the stronger tonal contrasts seen in the foreground bring it forward to the picture plane, and the curving path in the foreground takes the eye inwards towards the distant hill village.

it doesn't matter so much), with obvious brushmarks, the effect is similar to that of over-large bricks.

Aerial perspective

This is the term for the phenomenon that makes far-away objects appear less distinct than near ones. The tiny drops of moisture and dust in the atmosphere act rather like a veil of gauze, making colours appear paler and cooler (bluer) and reducing tonal contrast to the minimum. For anyone painting buildings in a landscape, or a group of distant buildings, pairing the two kinds of perspective, linear and aerial, is an infallible way of creating a feeling of space.

In watercolour, the best way of working is from back to front, starting with the pale tones and colours in the background and working up to stronger contrasts in the foreground. In opaque paints, it is usually easier to work from the darks to the lights, that is, from front to back. It can be tricky to get the tones and colours right the first time. What seems a pale and subtle colour on the palette often looks much too bright or dark on the canvas, but it is an easy matter to overpaint or scrape down and repaint.

▲ **Empire State** Ian Sidaway, *watercolour*
The tall building is very lightly suggested, as befits its distant position, but the most powerful element in terms of recession is the strong diagonal of the road, which effectively pushes the buildings away. Interestingly, this artist works extensively from photographs, and here he has used the distortions produced by the camera to good effect. The inward tilt of the buildings on the right increases the sense of space and also imparts a certain dynamism to the composition.

BRUSHWORK

· ·

People talk a lot about brushwork. How important is it?

Good brushwork produces a dynamic surface pattern or texture which adds an extra dimension to the subject.

Every aspect of the painter's craft makes its contribution to the finished picture, and the way you put on the paint is as vital a part of the language of painting as colour, tone, composition and correct drawing. A painting may imitate the three-dimensional world, but it is important to think of it also as a flat surface with an existence of its own. Good brush- or knife-work produces a dynamic pattern or texture usually referred to as surface interest, which not only creates an extra dimension but also helps to draw the viewer's eye to explore the subject itself. (I am at the moment talking about the opaque paints; in watercolours, surface interest can only be provided by the grain of the paper.)

Surface interest is by no means obligatory; in the early days of oil painting, artists prided themselves on blending their colours so subtly that no brushstroke was visible. If this is the way you naturally work, fine, but for most people one of the greatest charms of oil paint – and to some extent acrylic – is its thick buttery quality, which allows marks of the brush to become an integral and expressive part of the image.

▶ **Hill Village, Northern Spain** Michael Cadman, *oil*
This artist favours square-ended brushes, which make a very positive and distinctive mark, and are ideal for the flat surfaces of buildings. In order to preserve the unity of the composition the sky has been treated in the same way, and in the foreground he has suggested a patchwork of fields by using the brushstrokes in different directions.

▶ **Winter Sunlight, Normandy** Arthur Maderson, *oil*
Maderson works in the Impressionist tradition, using short, stabbed brushstrokes and close juxtapositions of different colours, giving a lovely impression of flickering light.

Variety within unity

Brushwork needs thought, however. You will not achieve either a pleasant surface or a successful description of your subject if you put on brushstrokes in a random and haphazard way. The most important thing to remember is that you should use the same *kind* of brushwork everywhere in the painting, while varying the size and direction of the strokes as appropriate. Newcomers to oils often go wrong because they try to mix different approaches, using large strokes of a square-ended brush in one part of a painting and little round dots in another, thereby destroying the unity of the picture.

Directional brushstrokes

You can also "draw" with the brush, using it to describe form by letting it follow the direction of the object you are painting. Paul Cézanne, who planned every aspect of his paintings with meticulous care, used directional brushwork to emphasize the rhythms he perceived in his landscape subjects as well as to describe the underlying structures of mountains, rocks and trees.

Watercolour

Brushwork is often thought to be unimportant in watercolour, but although little surface texture can be achieved, there is considerable scope for exciting and inventive use of the brush. There are watercolour painters who dislike the marks of the brush and work entirely in flat washes, but in most watercolours, brushmarks are discernible to a greater or lesser degree. Because the medium is such a fluid one, you can use it in a more calligraphic way than oils, making sweeping strokes or large, shaped blobs for clouds, smaller blobs and dots for foliage, flat, square strokes for buildings, and squiggles for reflections and small shadows.

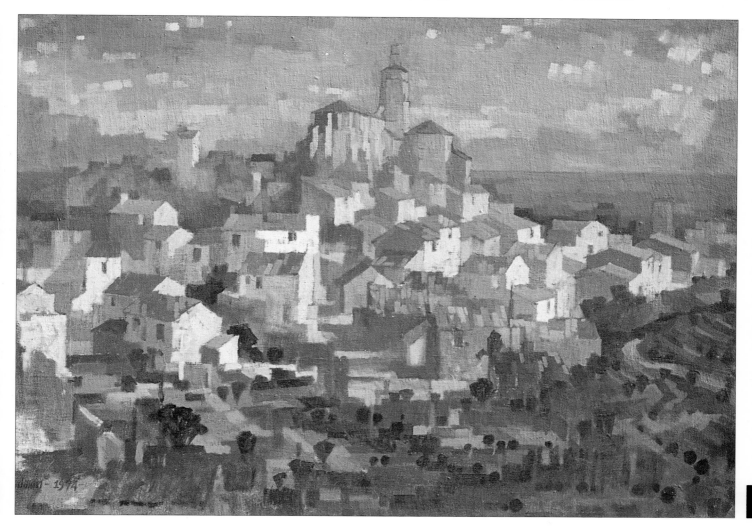

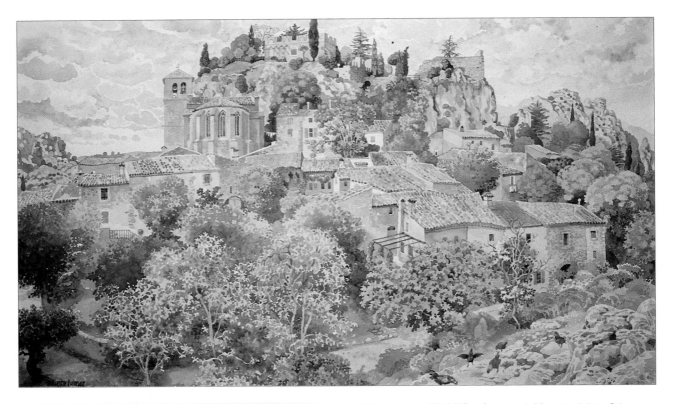

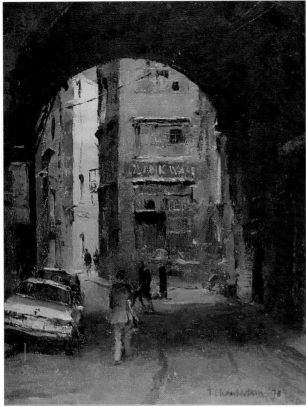

◄ Entrance to Clink Wharf
Trevor Chamberlain, *oil*
Chamberlain works on a small scale, but his brushwork is bold and expressive. Notice how he has created additional surface interest by varying the thickness of the paint. This can be seen particularly clearly on the central building, where the canvas is still visible in some areas, while details are picked out with horizontal slashes of thick, juicy impasto.

▲ Mouréze Juliette Palmer, *watercolour*
There is a common belief that brushwork is not important in watercolour painting, but it can play as vital a part as it does in oils. Here the artist has built up forms and textures with small delicate dabs to give a delightfully patterned effect.

► San Marco in the Rain
Douglas Lew, *watercolour*
This painting makes an interesting comparison with Juliette Palmer's above. Here the artist has used his brush in a much more graphic way, and the bold calligraphic squiggles in the foreground describe the reflections with accuracy and economy.

▲ **Road into Delph,
Autumn** John McCombs, *oil*
It is sound practice in oil painting
never to use two brushstrokes
when one will do. A few sweeps
of a loaded brush describe the
sunlit side of the house, while
the foliage and fields beyond are
treated with similar directness.
This kind of freshness and vigour
can only be achieved by working
confidently; if you have to make
corrections scrape the area
down and start again rather than
overworking.

LEARNING FROM THE
MASTERS
· ·
MONET

Claude Monet (1840–1926) was the central figure in the Impressionist movement and the one who inadvertently coined its name when he gave the title *Impression, Sunrise* to one of his early paintings. This is a lovely, atmospheric treatment of early morning sun reflected in water, and when exhibited it was picked out by a hostile critic as typifying the "half-finished" look of all the pictures by Monet and his friends.

The paintings exhibited at the French Salon, the only marketplace for art in those days, were in the main highly polished and minutely finished in every detail, and the few landscapes that were included were painted in the studio and usually much idealized. Monet's, on the other hand, were rapidly and freely done, and he always insisted on painting outdoors directly from his subject.

He lived to a ripe old age, but never wavered from his own artistic truth. The business of art was not to carry emotional or symbolic messages but to record reality as the eye perceived it at a particular time.

From 1890 Monet began to work on his "series" paintings, depictions of the same subject at different seasons and times of day. The best known of these are the Haystacks, the Poplars and the Rouen Cathedral paintings.

Rouen Cathedral: Harmony in Blue and Gold 1893/4
Oil on canvas
42 × 28¾ inches (107 × 73cm)
Musée d'Orsay, Paris

Monet could not by any stretch of the imagination be described as an architectural painter; his concerns were with the play of light on surfaces, but he was fascinated by the way the great grey slab of a building was transformed by golden evening light, mist or sunset. Many artists have subsequently taken up the idea of series paintings, whether for urban scenes, interiors or pure landscapes.

Using impasto

In all the Rouen series the paint used for the building is heavily built up, forming a dry, crusty, almost relief surface which wonderfully expresses the character of the old stone. (Unfortunately this cannot be seen too clearly in reproductions.) The sky, in contrast, is treated much more smoothly. The quality of the paint surface was of the utmost importance to Monet, and it is thought that these paintings were reworked later in the studio; such effects would be difficult to achieve at one sitting. In spite of being such an ardent advocate of outdoor work, Monet did sometimes cheat in this way, as he found it difficult to regard any of his work as finished.

Creating emphasis

On the left of the picture the paint is relatively thin, and this combined with the lack of definition gives a recessive effect. The thickly built impasto in the central area, where the paint appears almost to have been "carved" with bristle brushes, draws attention to it as the focal point. The dryness of the paint suggests that Monet may have used a technique invented by Degas, which involved draining some of the oil from the paint by squeezing it out onto blotting paper.

·········· Q & A ··········
BUILDINGS IN LANDSCAPE

When I paint buildings in landscape settings they look unnatural. Why?

Old buildings often appear to have grown out of the landscape, and this is the effect you want to achieve in your paintings.

This is something that can happen very easily until you get into the habit of seeing the picture as a whole instead of as a series of disparate parts. Buildings in landscapes, as opposed to townscapes, where the emphasis will naturally be on the architecture, have great potential for exciting compositions. They allow you to set up a relationship of contrasts between the rounded or curving forms of hills, trees and other natural features, and the clean straight lines and rectangular planes of the man-made structures.

Unless you are careful, however, the contrast may become too great, and this is usually the reason for the odd dichotomy seen in many amateur paintings, where the buildings look as though they have been tacked on as an afterthought.

Harmonious contrast

Old buildings, whether ruined castles, grand cathedrals or humble villages nestling in the folds of hills, often appear to have grown out of their local landscape, and this is the quality you want to achieve in your paintings. Your first consideration must be the prevailing light, because it is this more than anything else that ties the different parts of a scene together. A low sun will warm all the colours, not just some of them, while a cold winter light will cast a uniform bluish tinge. If you observe the effects of light accurately you will achieve the same harmony of colour and tone that you see in nature, and once you have this framework you can exploit contrasts of shape and texture without detriment to the picture.

The second consideration is technique. The landscape elements seem to be easier to draw and paint than buildings, so there is a natural tendency to treat them more broadly than the buildings. Even when the colours and tones have been well observed, the composition will not hang together if there are obvious dissimilarities in the way the different parts are painted. For example, if you are working in watercolour and decide to introduce some pen lines to give additional crispness to the architecture, you will need to use

line in other areas of the picture too.

And finally, you must be consistent in the amount of detail you put in. If you are treating the landscape in terms of broad areas of tone and colour, paint the buildings in the same way; don't let your anxiety about getting them right force you to put in every detail of doors, windows and building materials. If, on the other hand, it is the minutiae that attract you, make sure you carry the same approach through the whole picture.

▶ **Cottage in the Wood**

Michael Cadman, *oil*

The artist has employed a number of pictorial devices to achieve this perfectly unified composition. Firstly, he has produced a lively surface pattern by using the same bold brushwork all over the picture, without attempting too literal a description in any area. Secondly, he has repeated colours, one of the best ways of tying together the different elements in a painting. You can see that some of the yellows and creams of the building appear again in the grass and the flowers on the right, while the dark slatey greys of the roofs are very close to those of the foreground trees. And thirdly, he has organized the picture very tightly in terms of tone, with the foreground almost the same degree of darkness as the roofs and window, and the sky standing as a mid-tone between these and the sunlit house.

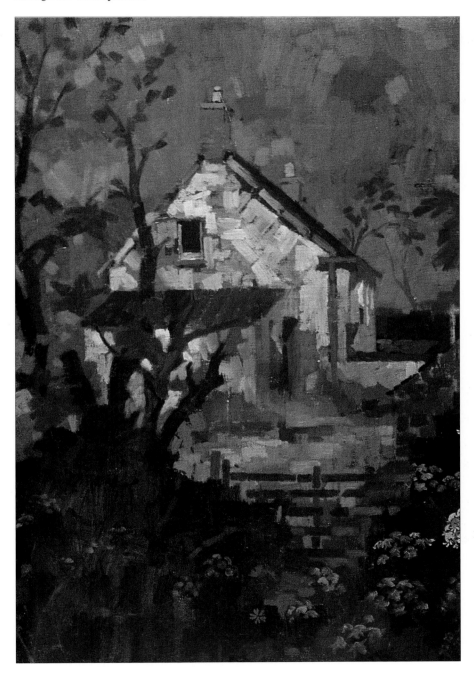

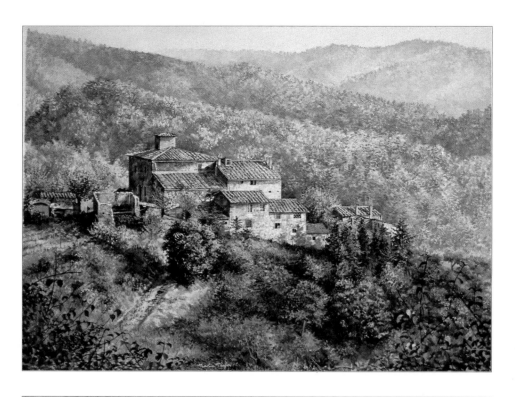

 View in the Chianti Region Martin Taylor, *watercolour*
The buildings are perfectly integrated into the landscape, appearing almost to have grown there.

▲ **Ambleside** Stephen Crowther, *oil*
The colours of the slate-roofed stone houses are repeated in the sky, while the dark greens form a series of links throughout.

▶ **Summer, Albert Memorial** Trevor Chamberlain, *oil*
The use of consistent brushwork all over the picture unites the building with the trees and grass.

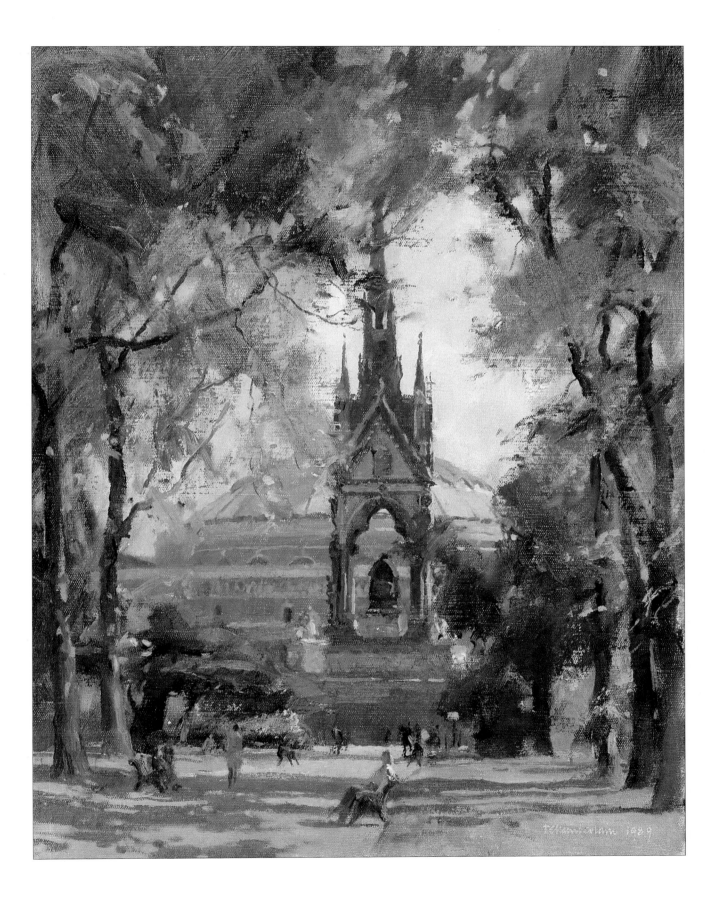

GORDON BENNETT
OIL DEMONSTRATION

This picture was based on a series of sketches and colour studies made during a prolonged stay in the Greek Islands. It is an oil painting with some acrylic underpainting, done on hardboard with a white gesso priming, and was completed in one working session.

▲ **1** The working sketch is propped up on another easel so that the artist can refer to it while he works.

▲ **2** Having made a charcoal drawing, he has reinforced some of the lines with thinned black paint applied with a fine brush. He likes to leave some of this dark line showing through the final paint layers to give structure to the composition. He now begins to block in broad areas with acrylic.

◀ **3** With the acrylic underpainting now dry (it dries very rapidly), the artist uses oils to establish the background colours. Until he has done this he will not be able to judge the colours for the buildings.

▲ **4** He uses bristle brushes for the large areas. These horizontal brushstrokes will later be overlaid with vertical and slanting ones to build up the crumbly texture of the whitewashed walls.

▲ **5** White paint is applied thickly, with deliberately uneven brushstrokes, over the grey underpainting. The paint is thinned with a small amount of linseed oil and white spirit where necessary, but in general is used neat.

▶ **6** A good rule for oil paintings is to work over the whole picture surface at the same time; if each area is completed in isolation it is more difficult to establish a relationship of colours and tones. Having covered most of the central area, the artist now turns his attention to the roofs, using a pointed sable brush to pick out one or two details of individual tiles.

▶ **7** Still working on the same part of the picture, he sharpens up the definition and increases the contrast between roof tiles and wall. This is helped by the differences in the consistency of the paint. That used for the wall is thick and juicy, but it has been thinned for the more linear treatment of the roofs.

◀ 9 The tiled roofs are one of the most important features, so the artist makes sure he is satisfied with them before he moves to another area. Notice that the shadows below the roof are still the original dark underpainting.

▲ 8 The choice of palette is a very personal one. Some artists like one they can hold as they work, while others prefer a table-top arrangement, as here. This is not in fact, a palette at all, but merely a piece of board. The state of artists' "palettes" varies very much also, Bennett likes to leave his old colours in place, only scraping them off now and again, as he finds they act as a reference for mixing new ones. Some artists, however, are fanatical about cleaning up at the end of each session.

◀ 10 The shadows seen in the photograph above have now been considerably modified by overpainting in a lighter colour related to those in the foreground. The latter is now given a touch of linear definition with a sable brush.

▶ 11 It was important to get the colour and tone of the doorway right to avoid it becoming confused with the roof. At an earlier stage, it was a darker and brighter colour, but this caused it to jump forward, so the artist has changed it to a less assertive one.

◄ **12** Small details like the arch over the door should be left until last. If you attempt to put them in too early they are likely to become spoiled by subsequent paint applications.

▲ **13** The thin, pointed shapes of the trees echo that of the bell tower, thus balancing the composition. They are given no more than a subtle hint of modelling; an over-detailed background can steal attention from the foreground.

▶ **Greek Island Village**
Gordon Bennett, *oil on primed hardboard*

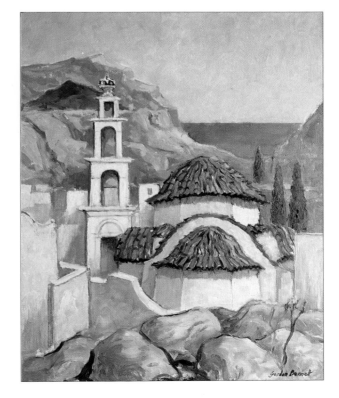

INDEX

Page numbers in *italic* refer to the illustrations

A

acrylics: broken colour 113
 impasto 101
 outdoor painting 95
 scumbling 101
 underpainting *138*
aerial perspective 127
Alexander, Naomi: *Memories 72*
 Twilight Interior 67
arches 28–9, *28, 30*
architectural styles 10–11
artificial light 66–7, *66–7*
atmosphere 114–15, *114–15*

B

Balasz, Suzie: *La Boucherie, Domme 118*
Beer, Richard: *Boucherie Chevaline 27*
 Entrée de l'hôtel 117
 Tuscan Farmhouse 114
Bennett, Gordon *112*, 138–41
 Greek Island Village 139
 Regent's Park Canal 37
blending, pastels 75
"blot-off" 101
Bonnard, Pierre 58, *58–9*
 Interior at Antibes 59
bricks 41, 96, *102*, 110
bridges 28, *28, 30*
broken colour 112–13, *112–13*
Brunelleschi, Filippo 15
brushwork 128–9, *128–31*
building materials 96–7, *96–7*

C

Cadman, Michael: *Cottage in the Wood 135*
 Hill Village, Northern Spain 128
 Red Village 107
canvases 94
carbon paper 45, 65
centres of interest 84
Cézanne, Paul 129
Chamberlain, Trevor: *Entrance to Clink Wharf 130*
 Spitalfields Market 55
 Sultry Afternoon in August 92
 Summer, Albert Memorial 136
 Summer Light, Pump Court 109

Sweeping Up, Spitalfields Market 121
 Terracotta and Stone, Venice 13
charcoal 44, *138*
chimneypots 29, *29*, 41
circles 29
cityscapes: centres of interest 84
 figures 120–1
 viewpoints 80–1
Clinch, Moira: *Church, Mykonos 106*
 Coca-cola Stall, Mexico 20
 The Rows, Chester 13
 Samarkand 99
 Summer Pavilion 12
collage 88, *88–9*
colour: aerial perspective 127
 atmosphere 114–15
 broken 112–13, *112–13*
 complementary 109, 115
 inside/outside paintings 69
 muddy 110–11
 notes 81
 photography 23
 shadows 108–9
 sketches 64–5, *64–5*, *121*, *124*
columns 29
complementary colours 109, 115
composition 84, *84–7*, 116–17
contrast 108–9, *108–9*
Corot, Jean Baptiste Camille 42
 View of the Roman Forum from the Farnese Gardens 42–3
Corsellis, Jane: *Girl in Mirror 61*
 Interior, Kuala Lumpur 122
 Interior, Maison des Palmes 70
 Interior with Flowers 71
 Interior with Turkish carpet 55
cropping 84
Crowther, Stephen: *Ambleside 136*
 Approaching Storm, Assisi 21
 Church of St Hilda, Hartlepool 91
 Seaward Bound 38
 Sparkling Morning 122
 Sunrise over Malcesine, Lake Garda 26
Cullen, Patrick 74–7
 Interior with Red and White Tablecloth 77
 Offices of Beale and Co., London 105
 Rooftops in Tuscany 81
 Window in Bologna 70
Curtis, David: *The Friday Market, Doncaster 122*

Midday Heat, New York 125
curves 28–9, *28–9*
cylinders 29

D

Degas, Edgar 42, *133*
domes 29
doors 177
 perspective 24–5, *24*
 proportions 40, 41, *41*
 views through 68–9
drainpipes 41
drawing frames 32–3, *32–3*, 53, 80, 94
dry brush technique 102, *102, 103*, 113
Dürer, Albrecht 32

E

easels 94–5
Elliot, John T: *Cornwall Station 99*
 Through the Door 71
 Winter Scene 92
ellipses 29, *29*
enlarging 45, 88
equipment, outdoor painting 94–5
Evans, Ray: *Alhambra Hotel, Granada 11*
 Clifford Street, Charleston 97
 Flour Mill, Oklahoma 10
 Harper's Ferry, Virginia 11
 Hotel Adonis, Bruges 11
 Hotel Virgilio, Orvieto 14
 London Wine Bar 97
 Manhattan Skyscrapers 10
 Mojacar, Andalucia 126
 Parador Nacional de Chinchon 11
 The Sign of the Angel, Lacock 14
 Skyscraper, Cleveland, Ohio 97

F

Ferry, David 88–9
field of vision 50, *50*
fixatives, pastels 75
focal depth, photography 22–3
focal points 56–7, 72
foreground interest *120*
foreshortening 84

G

Ganley, Stewart: *The Rose and Crown 99*

Garver, Walter: *Giants in the Evening 91*
 The Green Door 8
 Nantucket Front, August 35
Gibbs, Patrick: *San Gimignano 111*
gouache, 65, 95
grids 32–3, *32–3*, 45
grounds, tones 113
gum arabic *102*

H

highlights *23*, 109, 111
Hopper, Edward 67
horizon: reflections 36, 37
 vanishing point 16–17, *16–17*
horizontal lines, composition 84
Horton, James: *Interior at Les Planes 50*

I

impasto *43*, 100–1, *100–1*
impasto medium 101
Impressionists 42, 58, 104, 109, 112, 132
interiors: artificial light 66–7, *66–7*
 Bonnard 58, *58–9*
 domestic 56
 figures in 72–3, *72–3*
 looking out 68–9, *68–71*
 natural light 60–1, *60–3*
 perspective 50–1, *50–3*
 recording light 64–5
"intimisme" 58

K

knives: painting *100*, 101, *101*
 palette 94, 101

L

Le Nain, Louis 66
lenses, camera 22–3, *23*
Lew, Douglas: *San Marco in the Rain 130*
 Venetian Mural 26
Lidzey, John 46–9
 Church Hill, Winchmore Hill 49
 Interior with Desk and Chair 71
 St Paul's and Southwark Bridge 30
 St Paul's at Night 86
 Suburban Interior 1, 62
 Suburban Interior 2, 63
light: artificial 66–7, *66–7*
 and atmosphere 115

buildings in landscapes 134
and composition 117
contrast 108
natural 60–1, 60–3
outdoor 90, 91–3, 94
recording 64–5
tone 104–5, 104–7
location painting 94–5

M
McCombs, John: *Road into Delph,
Autumn 131*
View of Delph, Winter 83
Maderson, Arthur *113*
Winter Sunlight, Normandy 128
masking fluid 111
masking tape 103, 111
measurements 19, 40–1
Millichip, Paul: *Dodecanese 83*
Greek Town 108
Symi House 110
Town Gate 120
Monet, Claude 11, 64, 90, 132
*Rouen Cathedral: Harmony in Blue
and Gold 132–3*
Moran, Carolyne: *Cleohill Cottage
Porch 118*
A Corner of the Conservatory 54
Kitchen Window with Geraniums 69
The Striped Kimono 57
Window, Holiday Cottage 117

N
natural light 60–1, 60–3
Newberry, John: *Brasenose Chapel,
Oxford 54*
Keble College, Oxford 82
Pont d'Avignon 30
The Sheldonian, Oxford 20

O
oils *138–41*
broken colour 113
brushwork 128–9
colour sketches 65
contrast 108
impasto 100–1, *100*
outdoor painting 94
painting straight lines 111
removing 111
scumbling 101
one-point perspective *17*, 18
optical mixing *113*
Osborne, Doreen: *Church, Sifnos 106*
outdoor painting 94–5

P
painting boards 94
painting knives *100*, 101, *101*
palette knives 94, 101
Palmer, Juliette: *Mouréze 130*
pastel pencils 45
pastels *74–7*
colour sketches 65

outdoor painting 95
underdrawing 44, 45
pattern 96, 96–7
pencils: measuring with 19
sketches 60, 125
underdrawing 44–5, *103*
pens, sketches 125
perspective: aerial 127
curves and ellipses 28–9, 28–9
doors and windows 24–5, 24
interior 50–1, 50–3
linear 14–19, *14–21*, 126
one-point *17*, 18
photographs 22
recession 126
reflections 36–7
shadows 35
steps and stairs 25
two-point 18–19, *18–21*, 24–5
and viewpoint 33
photocopies 45, 64, 88, *88–9*
photographs 45, *45*, 88
composition 85
of figures 121
interiors 61
townscapes 81
working from 22–3, 22–3
Plumb, John: *Reflections at Ockham
39*
Shepperton Manor 39
Pointillism *113*
proportions 40–1, *40–1*

R
recession 126–7, *126–7*
reflections, in water 36–7, 36–9
Rembrandt 66, 101
removing paint 101
Renaissance 15, 32
retarding medium 95
roofs: perspective *16*, 18–19 19
scale 41
Roxby Bott, Dennis: *West Pier,
Brighton 86*

S
scale 41
scraping down 59, 101
scumbling *100*, 101
Seurat, Georges *113*
sgraffito *100*, *101*
shadows 34–5, 34–5
artificial light 67
colour 108–9
and composition 117
contrast 108
double source 67
interiors 61
morning and evening 90
photography 23
Sidaway, Ian: *Composition with Palm
Trees 78*
Empire State 127
Roussillon 86

Vesuvio Bakery 119
sight-size 40
sketchbooks 124
sketches 23, 124–5, *124–5*
artificial light 66
colour *121*, 124
composition 85
figures 121, *121*, 125
focusing in 116–17, *116*
natural light 60–1, *60*, 64–5, 64–5
recording texture and pattern 96
tonal *104*
townscapes 81
underdrawings 44, 45
space, recession 126–7
spattering 102–3, *102, 103*
squaring up 44, 45
stairs and steps 25
straight lines 111
sunlight 90
shadows 34–5, 34–5
surface interest 128–9
symmetry 84, 117

T
Taylor, Martin: *Nextdoors 7*
Behind Palmer's Greengrocers 92
Casa Speranza 26
Farmhouse Door 119
Rochford Barns 84
View in the Chianti Region 136
View of Florence 21
texture 88, 96, 96–7, 100–3, *100–3*,
113, 117
tiles 41, 110
Titian 101
tone 104–5, *104–7*
aerial perspective 127
atmosphere 114, 115
high contrast 108
toned grounds 113
tonking 111
Tonks, Sir Henry 111
Tookey, John: *Canal at Farnhill 38*
Customs House, King's Lynn 114
Venetian Backstreet 107
townscapes: figures 120–1
perspective 126
viewpoints 80–1
transferring drawings 44, 45
Turner, J.M.W. 11, 90

U
Uccello, Paolo 15
underdrawing 44–5, *44–5*, *103*
underpainting 138

V
vanishing points 16–19, *16–19*, 24–5,
25, 36
verticals: in photographs 22, 22
receding 18
viewfinders 56, *56*, 80
viewing frames see drawing frames

viewpoints 33, 50, 80–1, *80–3*, 116
Vuillard, Edouard 58

W
Walker, Sandra: *Reflections 6*
Bowery 1, 8
Behind Waterloo Station 15
Lower Manhattan 98
Randall Street, London 30
water, reflections 36–7, 36–9
watercolours: aerial perspective 127
broken colour 113
brushwork 129
buildings in landscapes 134–5
colour sketches 65
contrast 108
masking 111
outdoor painting 94–5
removing 111
texture 102
underdrawing 44–5
washes 124
wet in wet 46–8
wet on dry 48
Watson, Neil: *Windows and Balconies
2,*
Charleston, South Carolina 12, 115
wax resist *102, 103, 103*
wet in wet 46–8, 86
wet on dry 48
white spirit 94
windows *116, 117*
arched 28
perspective 24–5, 24
proportions 40, 41
views through 68–9
wood, texture 96

CREDITS

The author and the publishers would like to extend their grateful appreciation to all the artists who submitted their work for this book, of which only a selection appears on these pages.

We would also like to thank the following whose names do not appear alongside their work.

Ray Evans for his illustrations on pages 16, 17, 18, 19, 24, 25, 28, 29, 34, 35, 36, 40, 41, 52, 53, 66, 67, 80, 85, 97, 120, and 121; the Bridgeman Art Library for the photograph on page 42; Trevor Wood for his photography of John Lidzey's paintings on pages 46, 47, 48 and 49; The New Academy and Business Gallery, London, for the photograhs on pages 55, 61, 70, 71 and 123; David Kemp for his illustrations on pages 56 and 96; John Lidzey for his paintings and drawings on pages 60, 62, 64, 65, 94, 95, 104, 105, and 116, and Jim Daler for permission to reproduce the painting on page 62; David Ferry for the collage demonstration on pages 88 and 89; David Curtis for his paintings on pages 100, 103, 124 and 125, Richard Hagen Limited, Broadway, Worcestershire for permission to reproduce the painting on page 125; The New Hurlingham Gallery, London, for the photograph on page 111; Quarto Publishing plc for the photograph on page 132; Gordon Bennett for the oil demonstrations on pages 138, 139, 140 and 141.